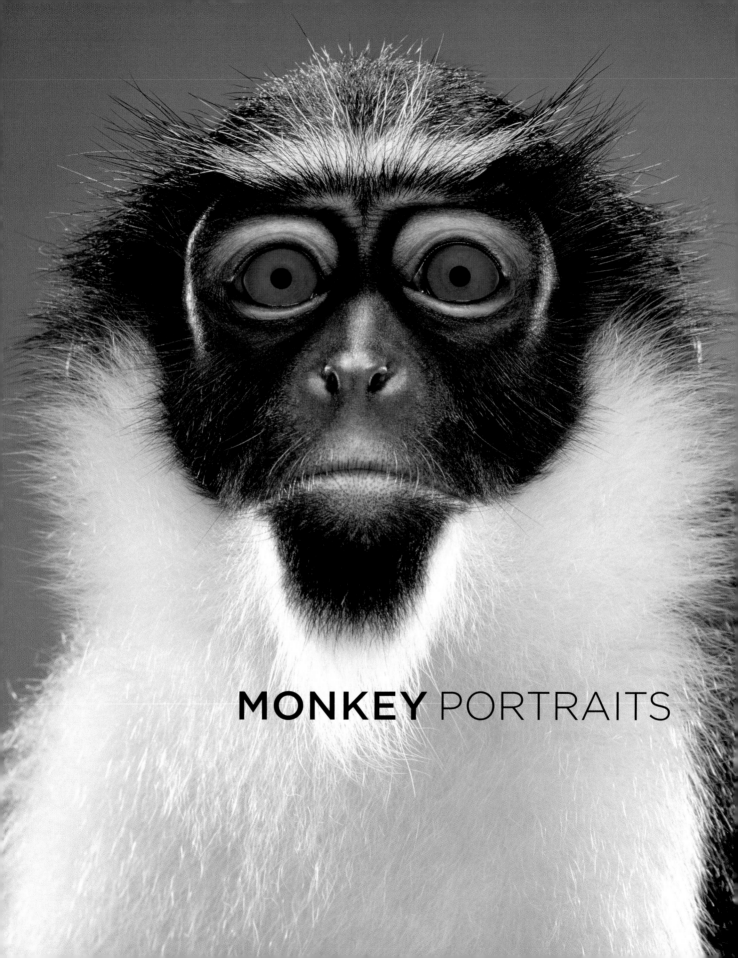

MONKEY PORTRAITS

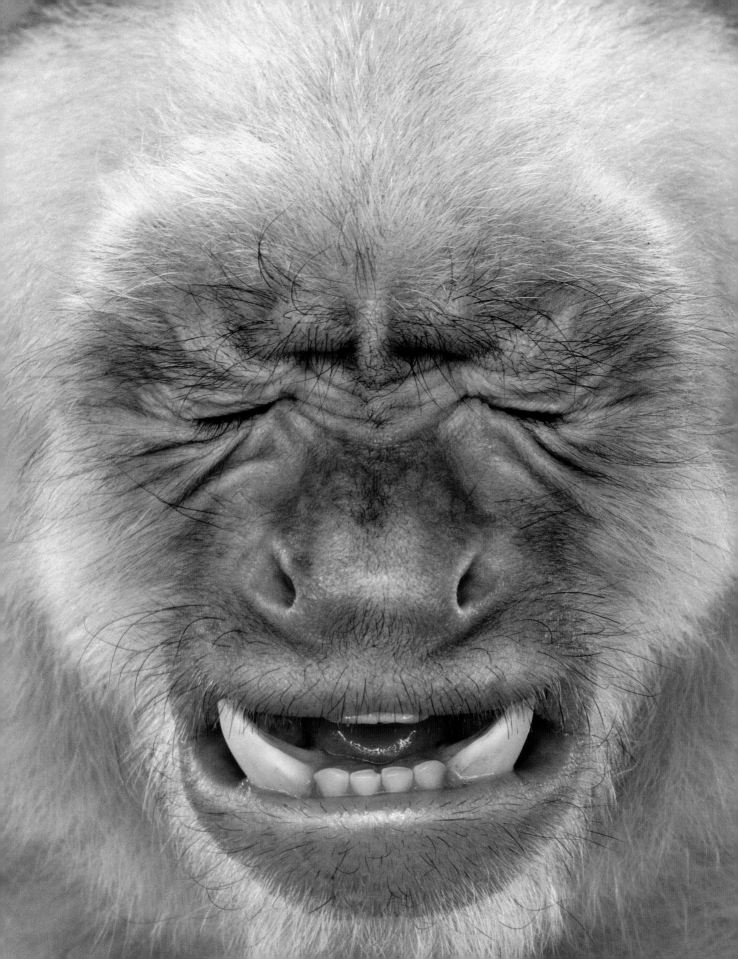

Photographs by
Jill Greenberg

Foreword by
Paul Weitz

MONKEY PORTRAITS

Bulfinch Press
NEW YORK • BOSTON

Bulfinch Press
Hachette Book Group USA
1271 Avenue of the Americas, New York, NY 10020
Visit our Web site at www.bulfinchpress.com

First Edition: September 2006
Second Printing, 2007

Library of Congress Cataloging-in-Publication Data

Greenberg, Jill.
 Monkey portraits / Jill Greenberg. — 1st ed.
 p. cm.
ISBN-10: 0-8212-5755-2 (hardcover)
ISBN-13: 978-0-8212-5755-5 (hardcover)
1. Photography of primates. 2. Apes — Pictorial works. 3. Monkeys — Pictorial works. I. Title.

TR729.P74G57 2006
779'. 3298 — dc22

 2005037068

Design by Gary Tooth / Empire Design Studio
Printed in Singapore

To my little monkeys, Violet and Zed,

and my great ape, Rob

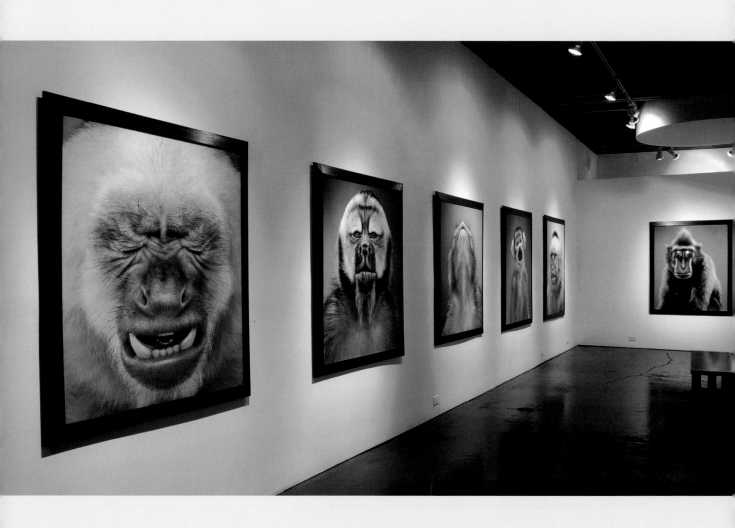

Paul Kopeikin Gallery, 2005

FOREWORD

I attended an exhibit of Jill Greenberg's monkey portraits at the Paul Kopeikin Gallery in Los Angeles last year. Although I had met Jill socially before, I didn't put two and two together. I just went because I was attracted by the photo on the postcard invitation. So I was surprised to see a number of people I knew at the exhibit, many of whom I hadn't seen in years. As more and more old friends and acquaintances entered the gallery, plastic wine cups in hand, I had a feeling of discomfort and dread. I had changed a lot since I last saw most of them. They seemed as nice and as intelligent as ever, but they made me think of a weird, often unhappy guy I used to know – myself.

That was the perfect state of mind to be in while I looked at Jill's monkey and ape photos. The neutrality of the backgrounds allowed me to focus on their faces and their body language. There was a temptation to anthropomorphize them, but I don't think that is what drew me to the photos. I think it was the way the images held up a mirror to my own confusion. There is a degree to which our own humanity is comprehensible, and a degree to which our movement through time and toward death simply doesn't jibe with our attempts to be presentable.

These pictures make sense and they don't. They are beautiful and grotesque. They resonate with exploitation and respect. They're funny and sad. I like them a lot.

I bought a couple of huge prints that night, one for myself and one for my brother, with whom I share the superstition of always putting a monkey in any film I'm working on (it has devolved to a sock monkey in my current film). I'm relieved to find that the print I bought for myself is simply titled "The Monkey." The subject's name is apparently Katie, and she has starred in *Bruce Almighty*, *Friends*, and an Excedrin commercial. While I can't comprehend it, her worried, intense expression is extremely familiar.

Paul Weitz
filmmaker

INTRODUCTION

I began photographing monkeys and apes by accident. I had booked a small white capuchin named Katie for an advertising job. She was supposed to be having a tea party with two little girls in a pink room, standing on the table banging pots and wearing pink striped bloomers. For other assignments, I had shot penguins, lions, and albino pythons, but this was the first time I had photographed a monkey. Since I had a bit of extra time and a nice client, I decided to do a portrait of Katie.

When I got the contact sheets back, the images startled and amused me. Katie's expressions were so human and her intelligence seemed so obvious. I realized I had discovered a new subject—one perfect for social commentary. Since this work happened to commence in October 2001, just after the tragic events of 9/11, I was discovering my own sociopolitical awareness of the world. These animals' expressions allow an interpretation that can be perceived as passing judgment on the behavior of their genetic cousins. Ultimately I ended up having to reshoot the ad with a toy poodle, since the client decided the monkey looked too menacing—not quite the effect that they wanted to sell to moms in the Midwest.

I photographed more monkeys and apes whenever I had a chance or felt financially free enough to lay out the funds for these animal actors, with their attendant trainers and handlers. The project has taken about five years to complete, and the subjects were photographed at my studios in New York and Los Angeles, as well as at Parrot Jungle in Miami. In all, I have photographed more than thirty different primates, about twenty different species: marmosets, mandrills, capuchins, macaques, orangutans, and a

chimpanzee, to name but a few. They all have resonated with me in different ways. I love the wisdom in the face of Jake, the older orangutan. He is only five years old but looks like an old man. Another favorite is Josh, the celebes macaque, who is on the cover. His black hair, amber-colored eyes, and long face make him look almost unreal, like a cartoon character.

What became apparent as I was making my selections after each shoot was that I was attracted to the images where the subjects appeared almost human, expressing emotions and using gestures I thought were reserved only for people. The formal studio portrait setting adds an air of both seriousness and humor. Some people have commented that the animals resemble friends or relatives. Sharon Stone remarked as I was shooting her, that she has "sat in studio meetings with guys like that," referring to "Haughty." Indeed, monkeys are not as high maintenance as many of the subjects I regularly photograph, albeit markedly more difficult to communicate with and give direction to. Of course, with primates, I don't have to be concerned with making sure they look "beautiful" or retouching them to appear flawless. They are us and the opposite of us at the same time since they share none of our cultural constraints on behavior or appearance. They seem to be looking back at us, sometimes judging, sometimes in shock. Is it something we've done? Maybe it is just that some of us are trying to pretend we aren't related. For anyone who doubts Darwin (ahem, Mr. President), look in the monkey mirror and think again.

Jill Greenberg

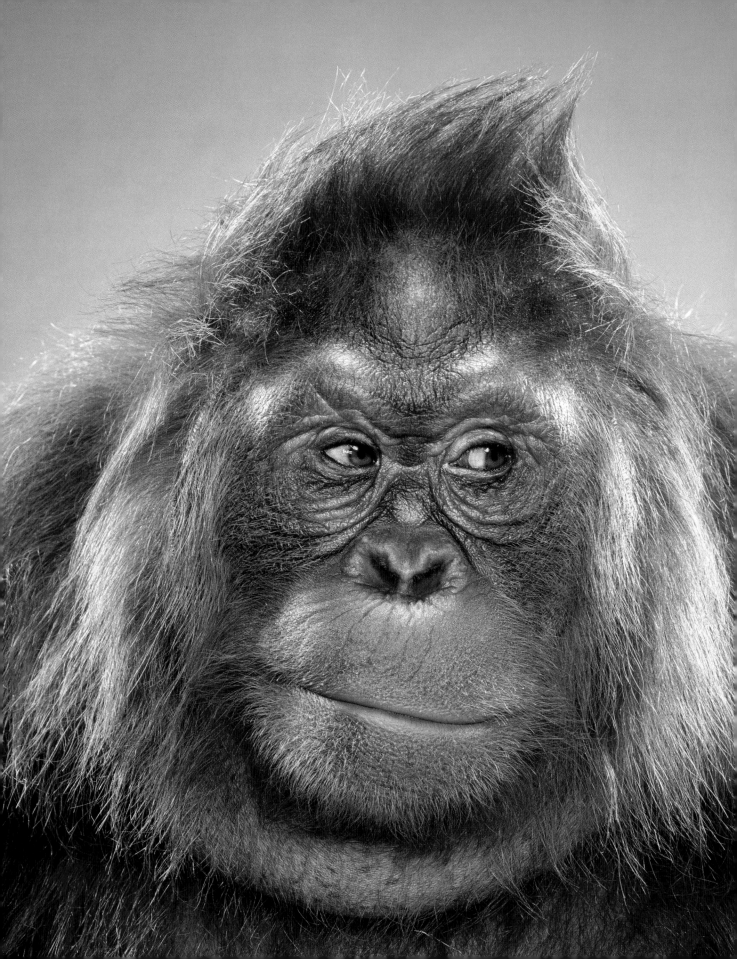

THE **PORTRAITS**

Heatmiser

Often I have gazed into a chimpanzee's eyes and wondered
what was going on behind them.

JANE GOODALL

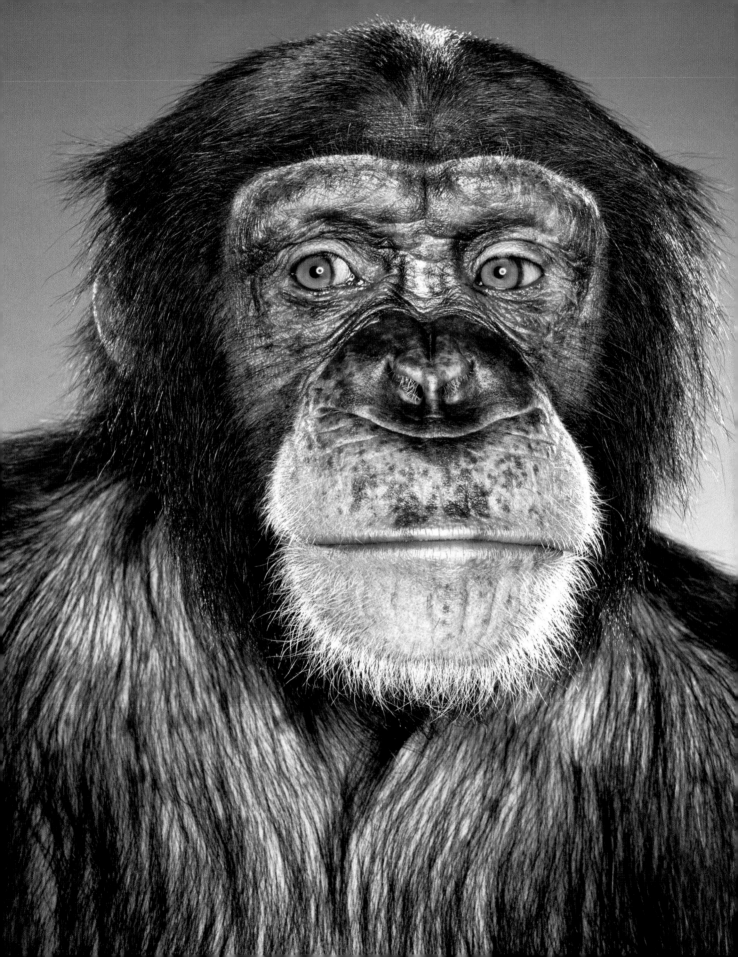

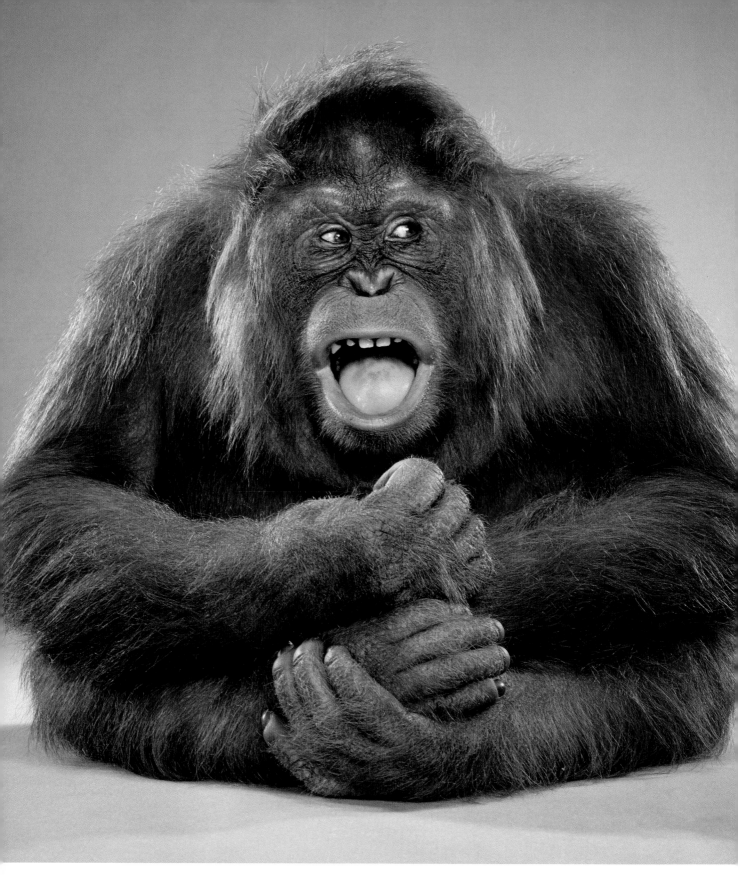

Contrarian

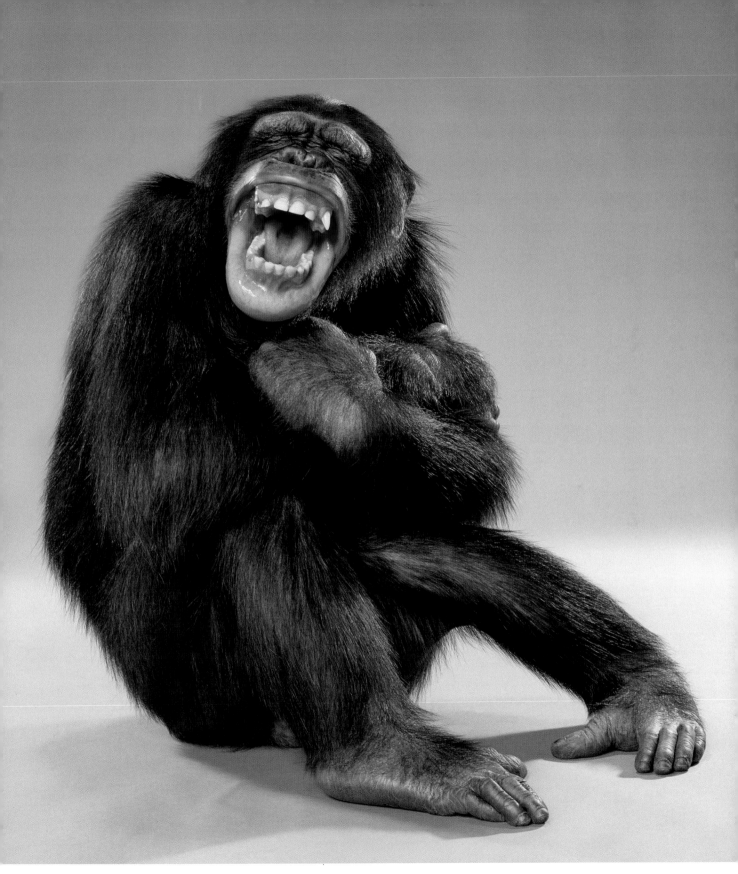

Sick

Offput

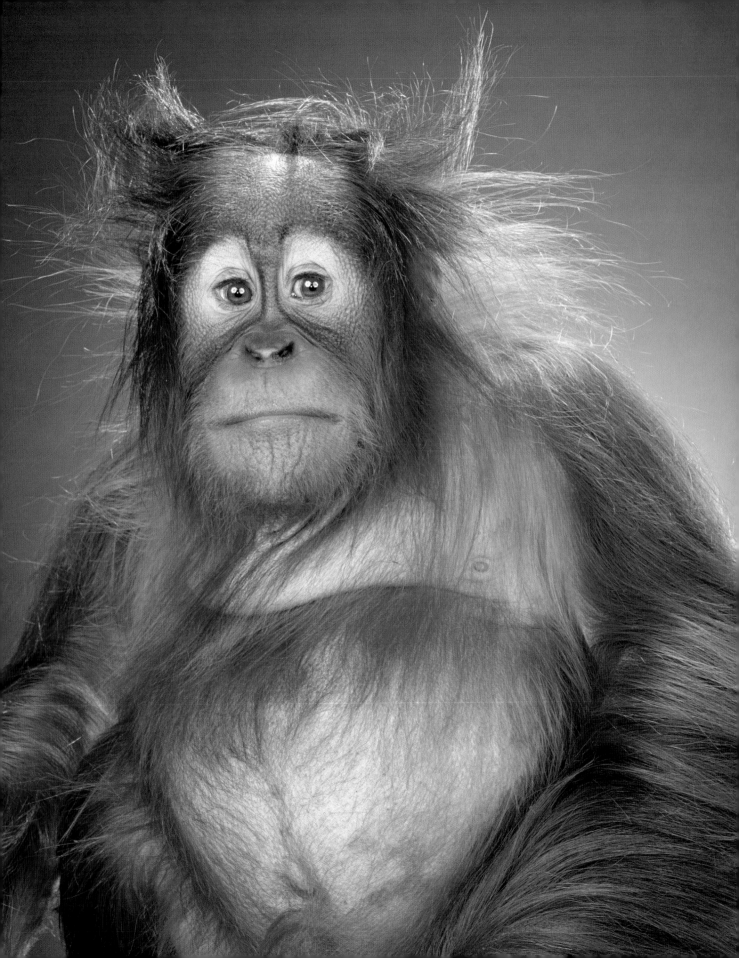

Rocky Portrait

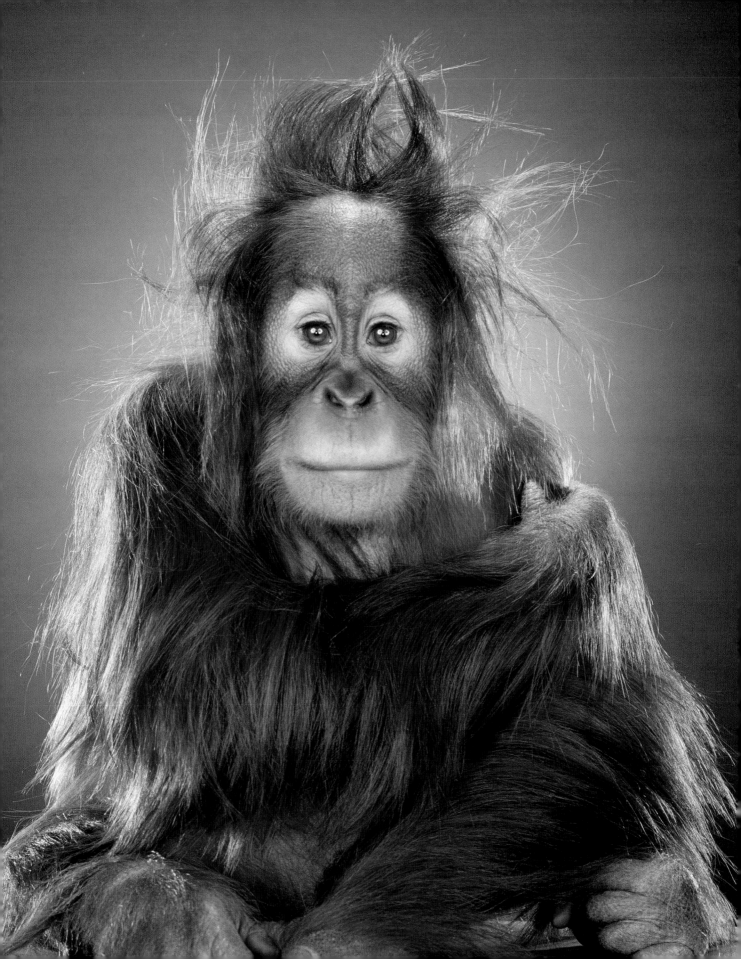

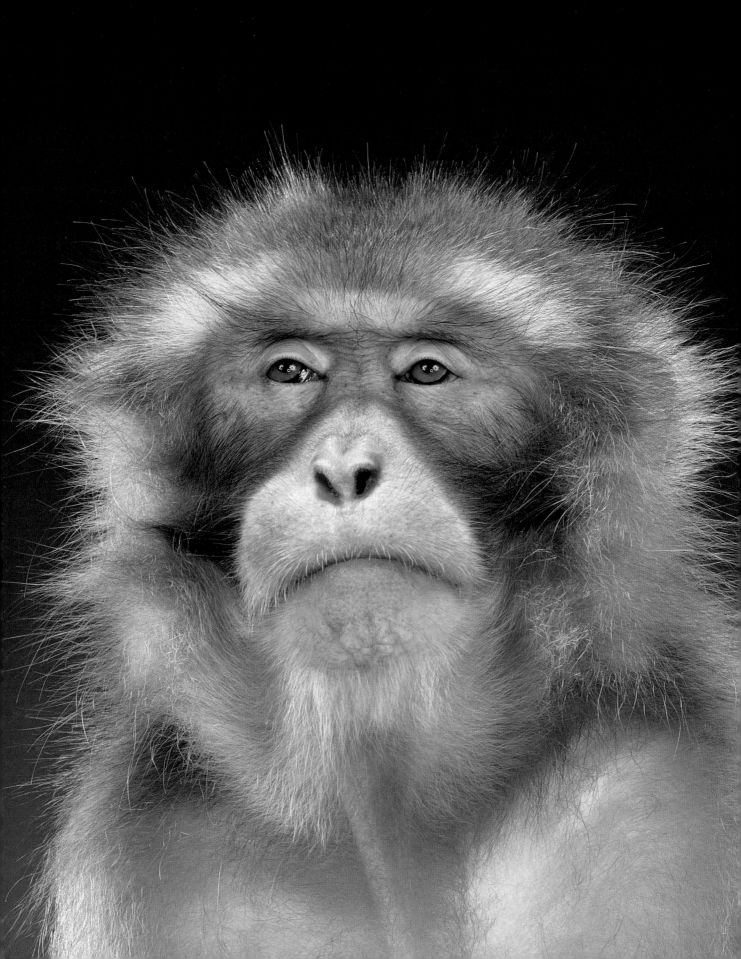

Monkeys are superior to men in this:
when a monkey looks into a mirror, he sees a monkey.

MALCOLM DE CHAZAL

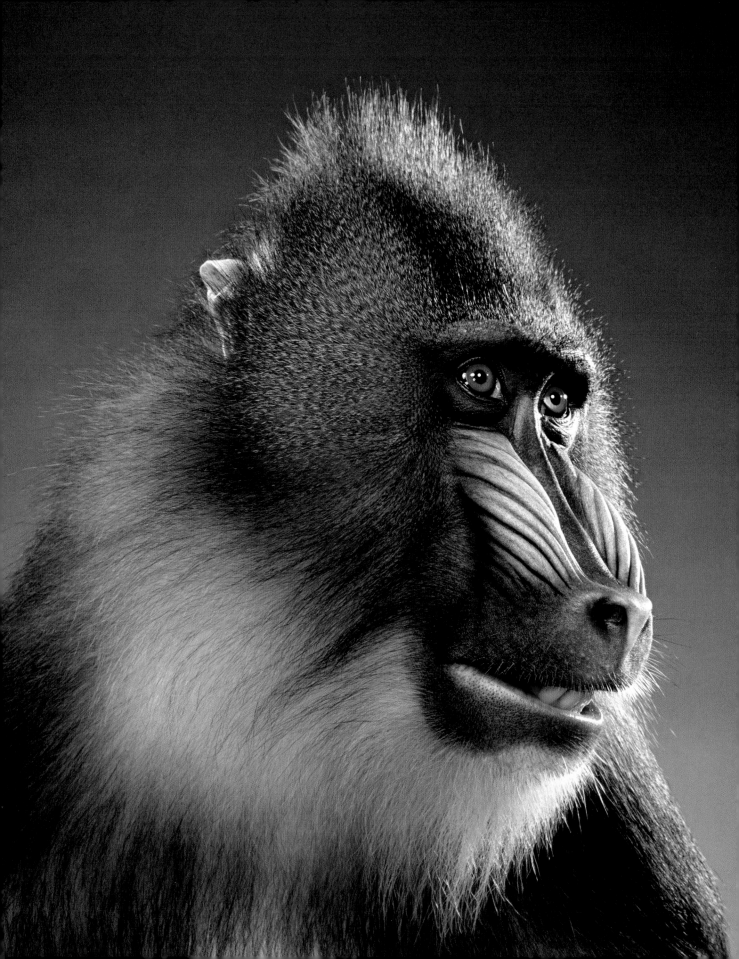

Kongo Portrait

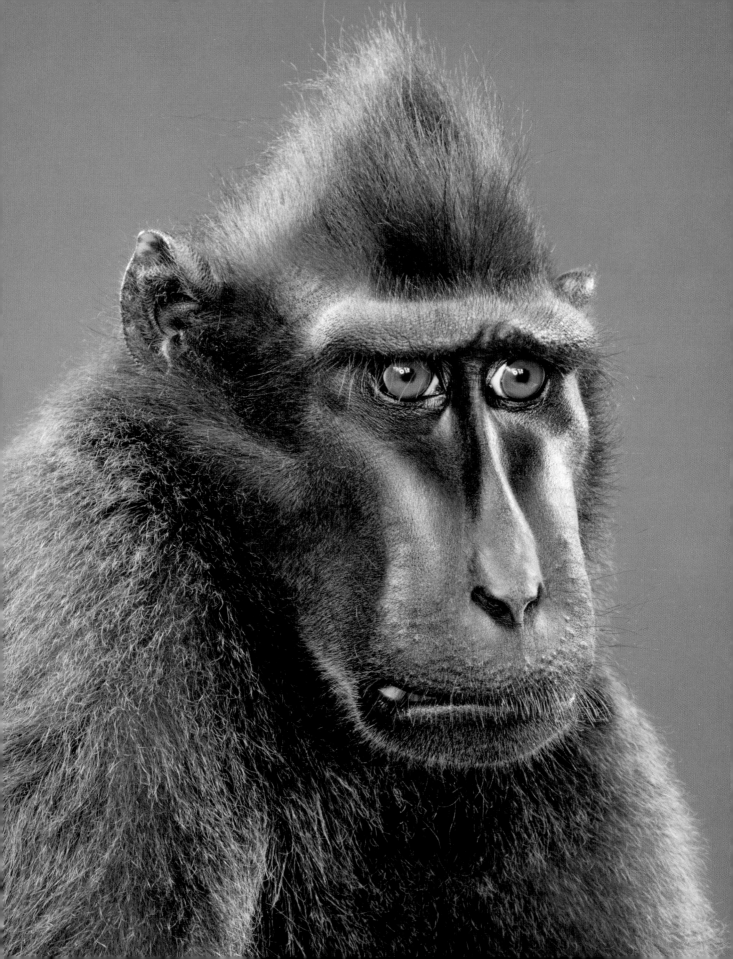

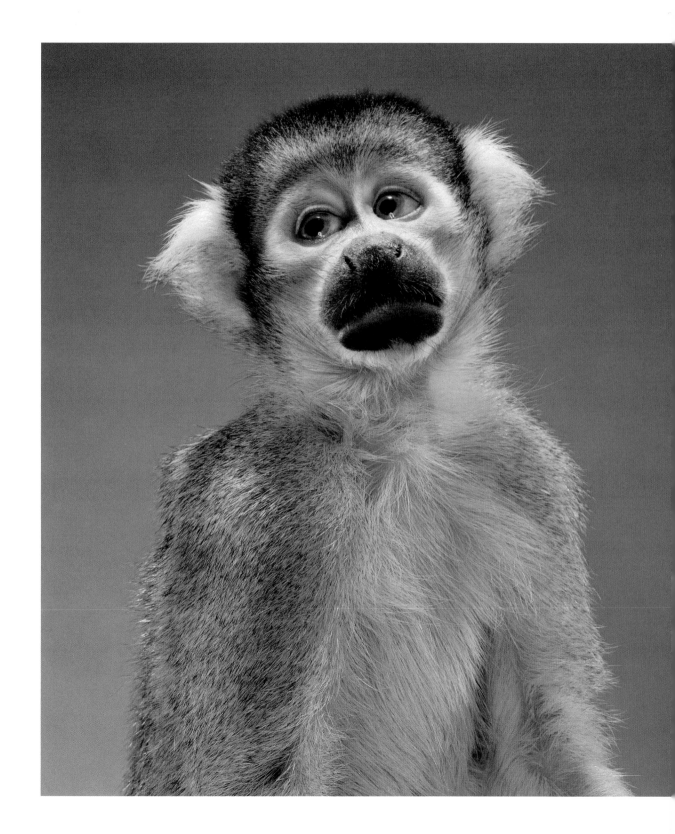

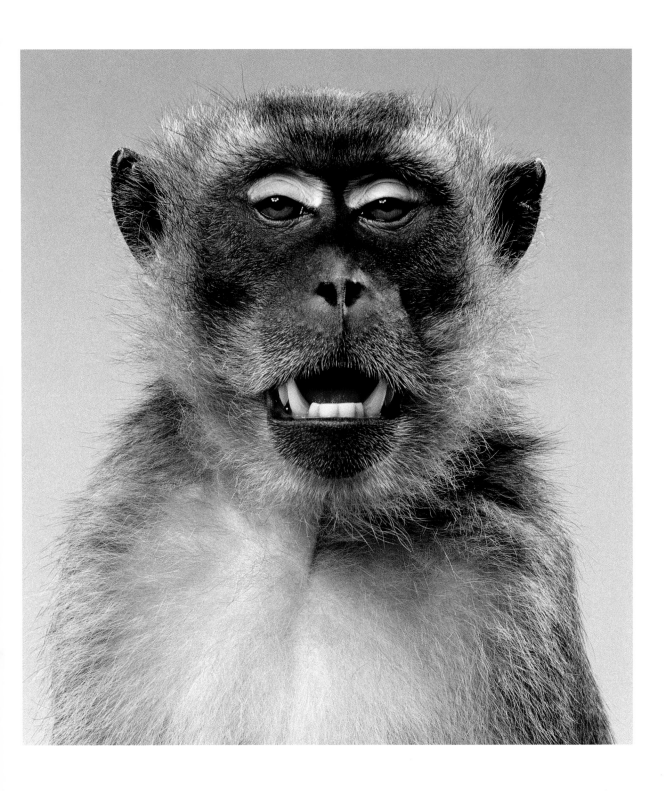

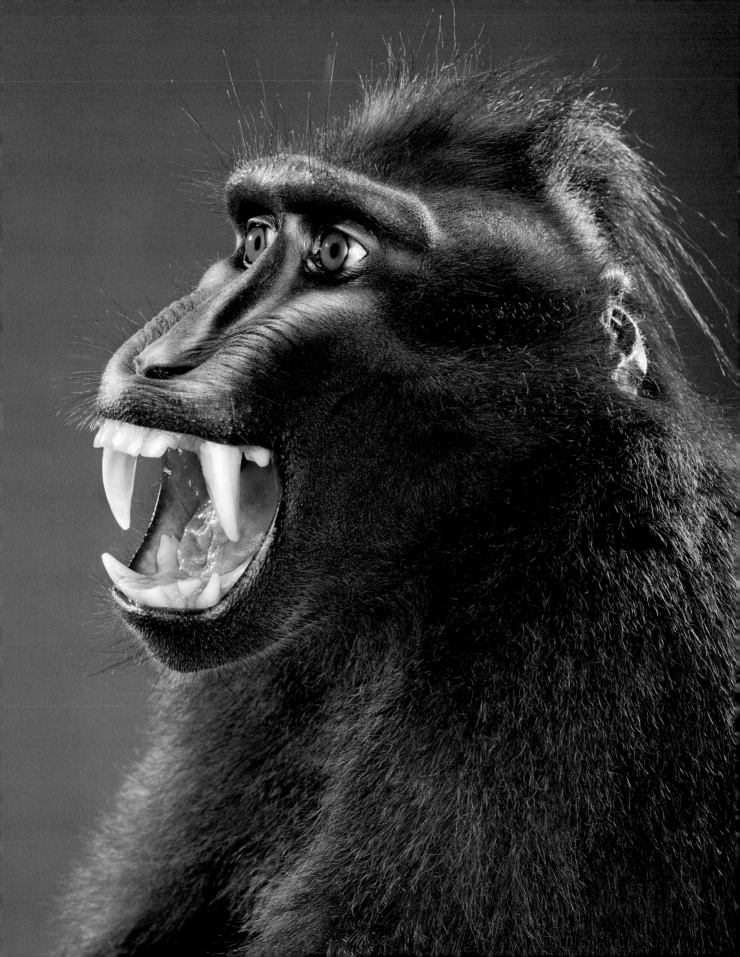

Still

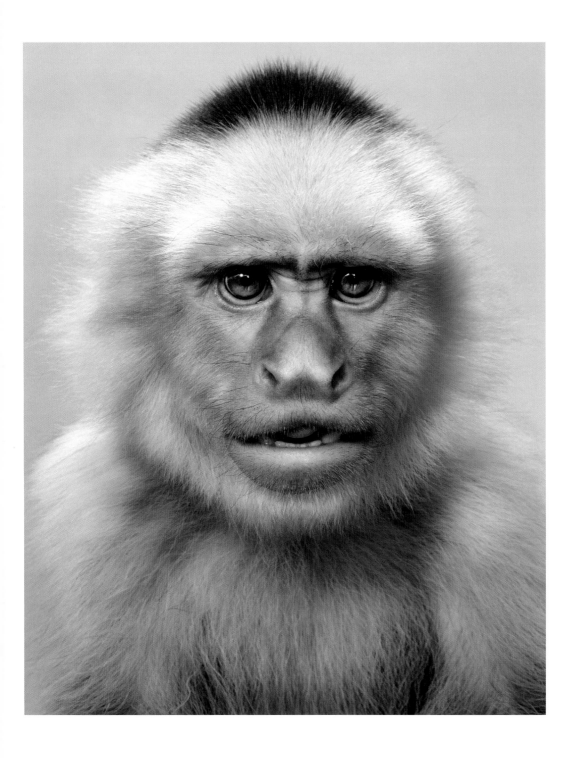

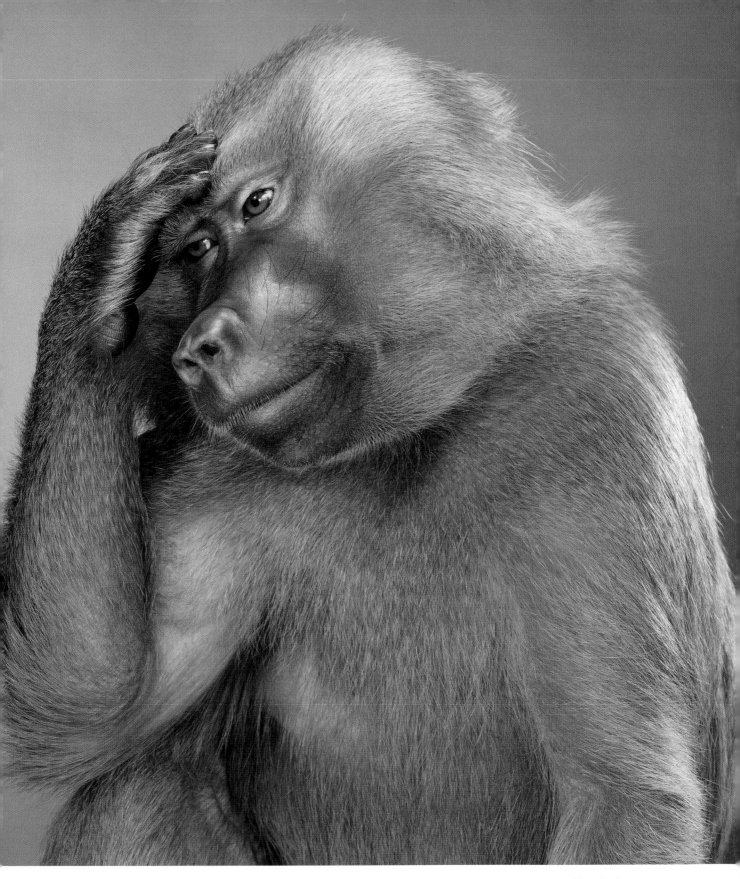

Headache

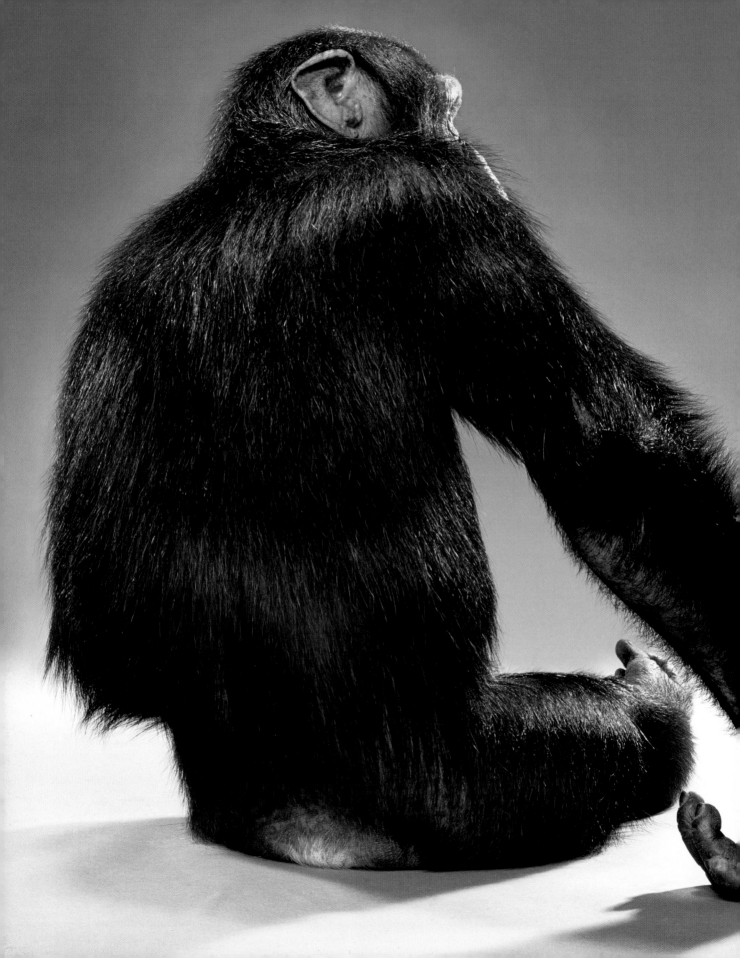

His life among these fierce apes had been happy.
EDGAR RICE BURROUGHS

Triangle

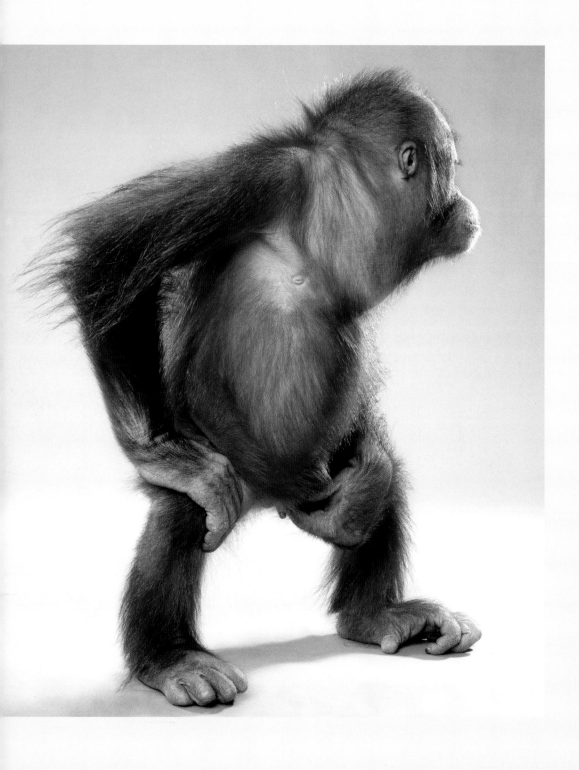

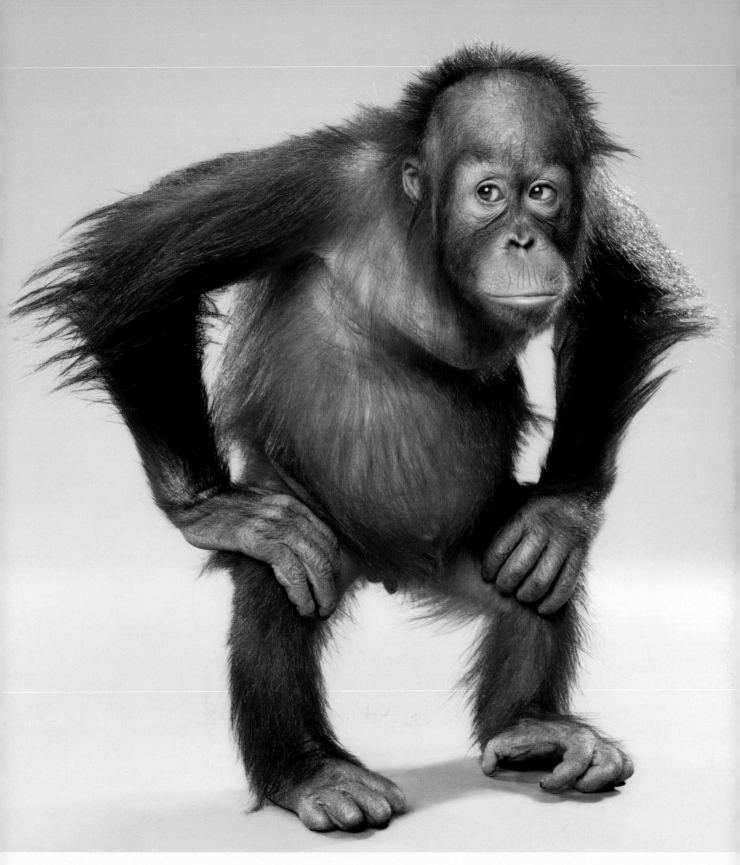

Following pages, left to right: The Cuddler, Money

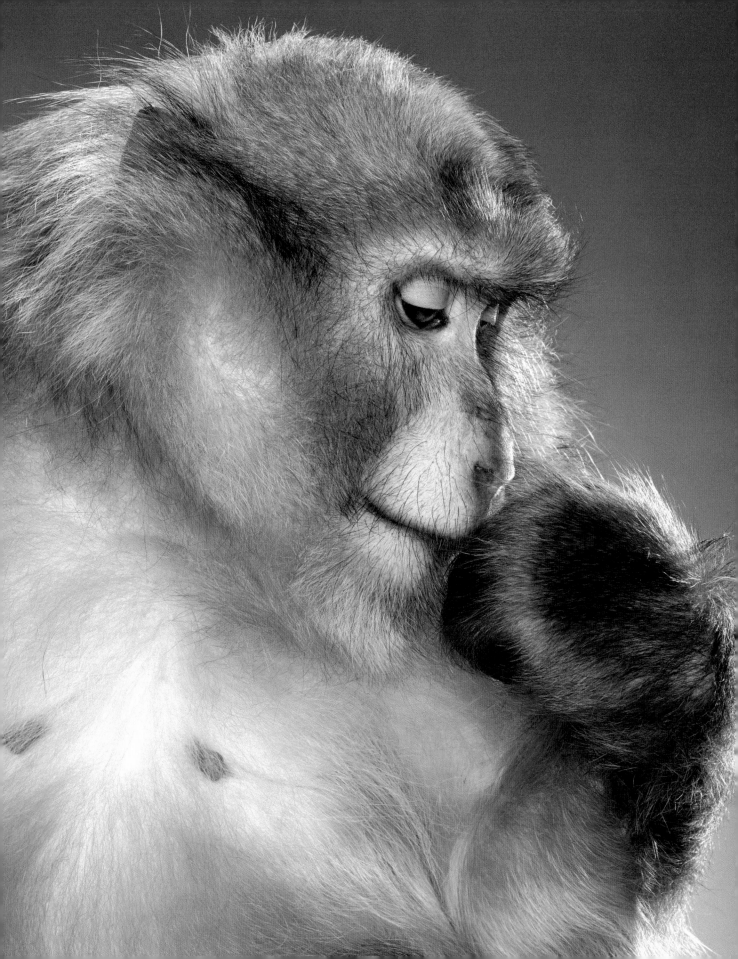

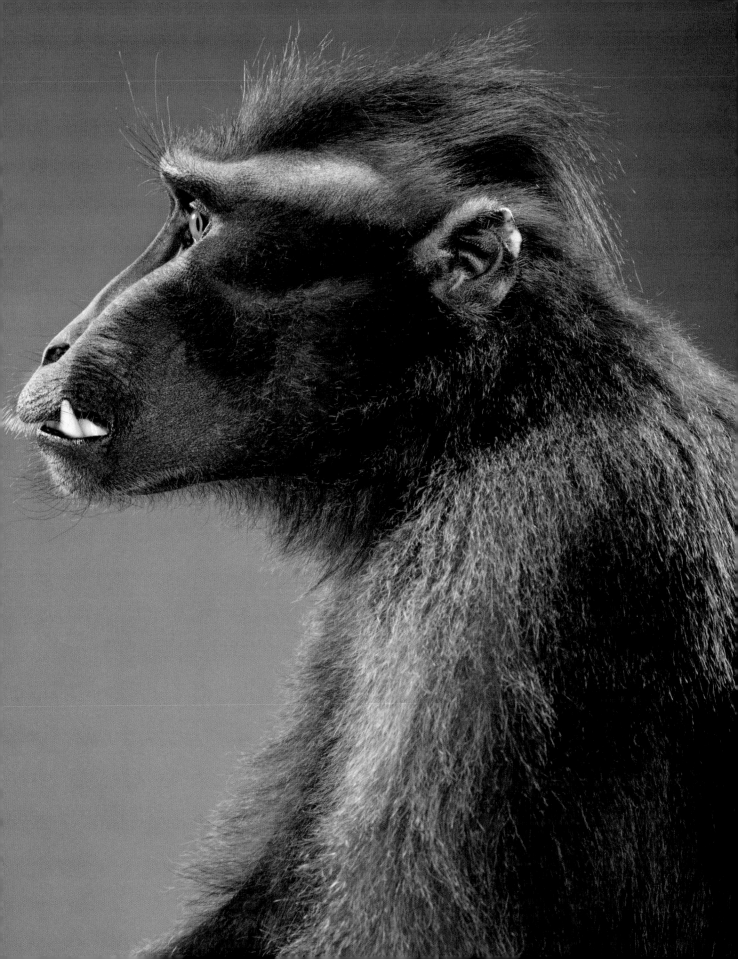

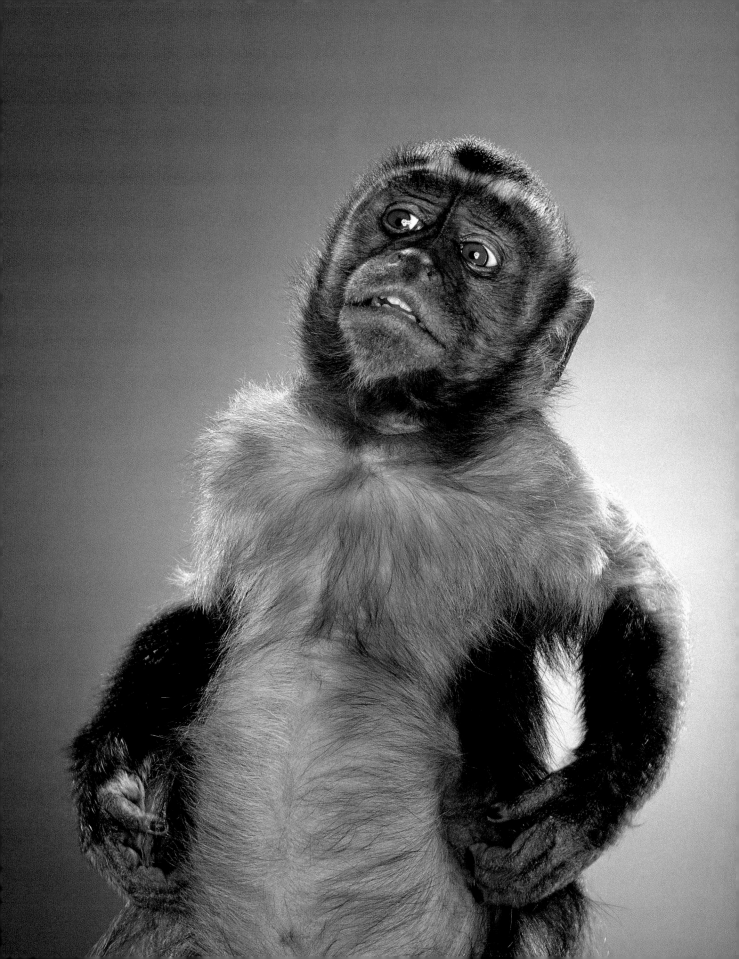

The monkey wears an expression of seriousness which would do credit
to any college student, but the monkey is serious because he itches.
ROBERT MAYNARD HUTCHINS

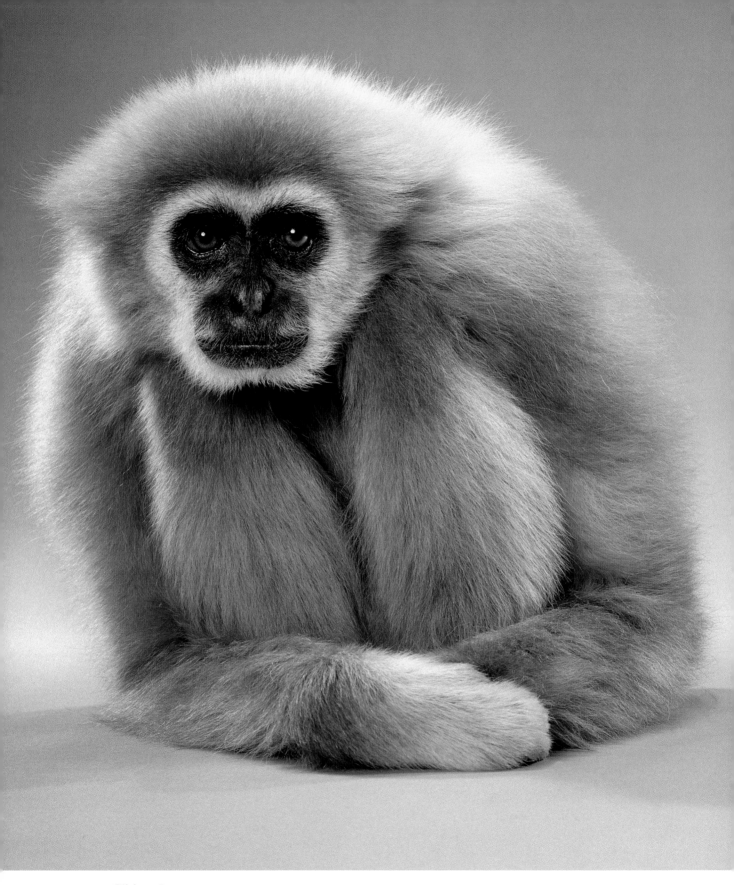

Gibbon Lean

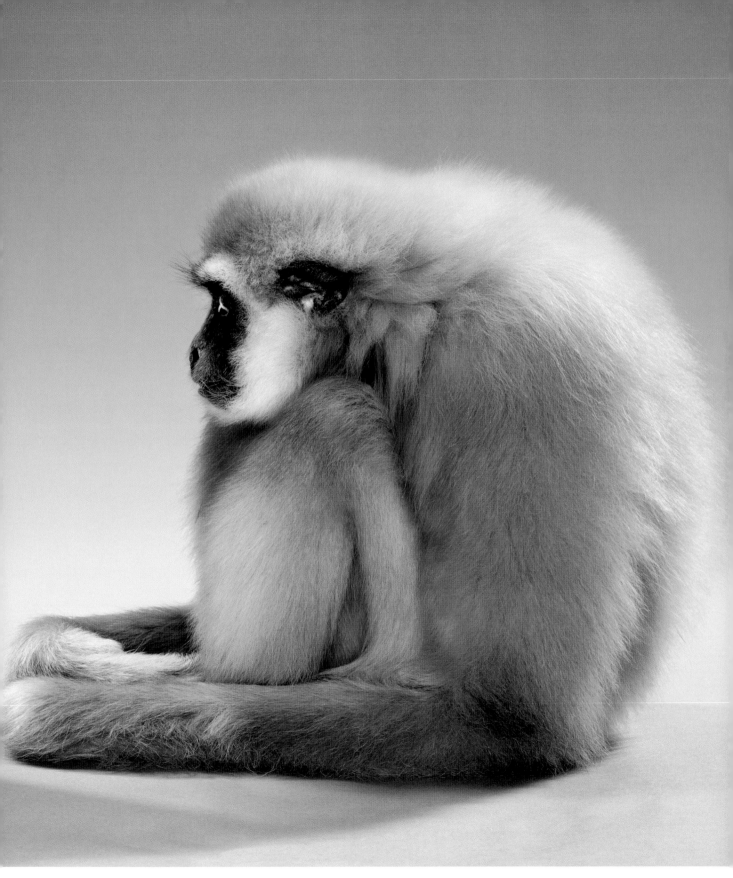

Gibbon Profile

Chatty Katie

Following pages, left to right: Farklempt Mandrill, Guilty

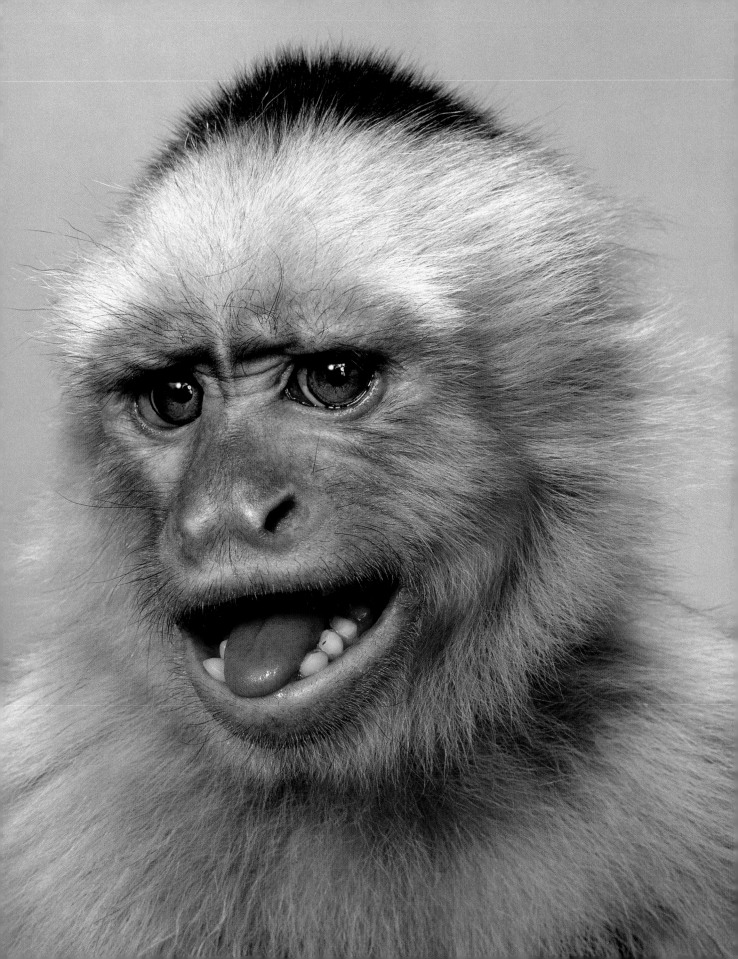

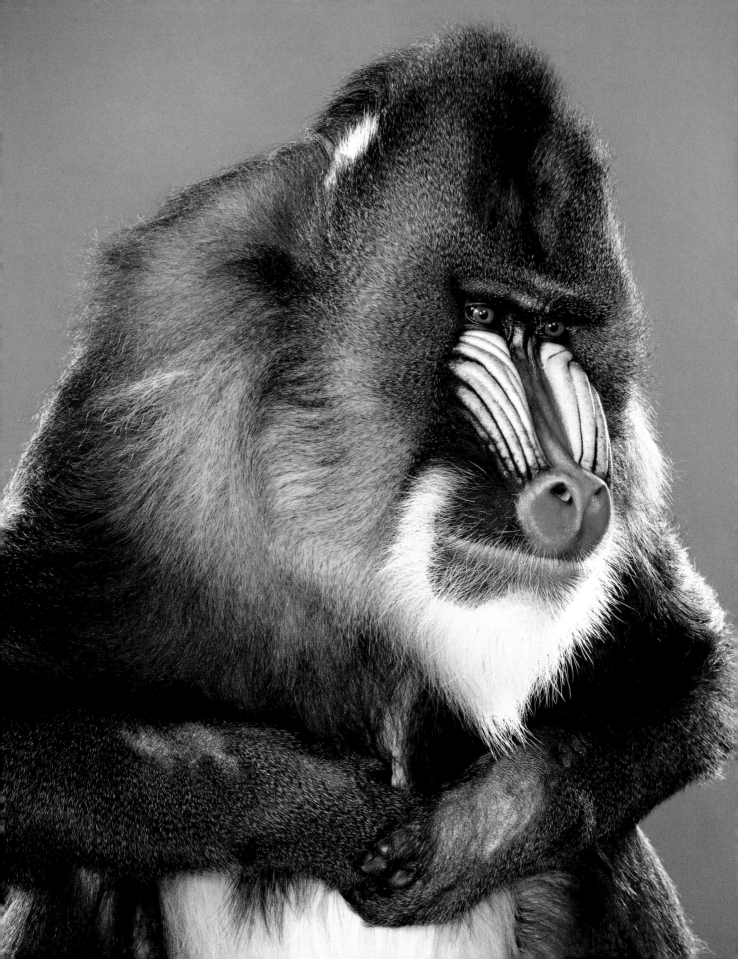

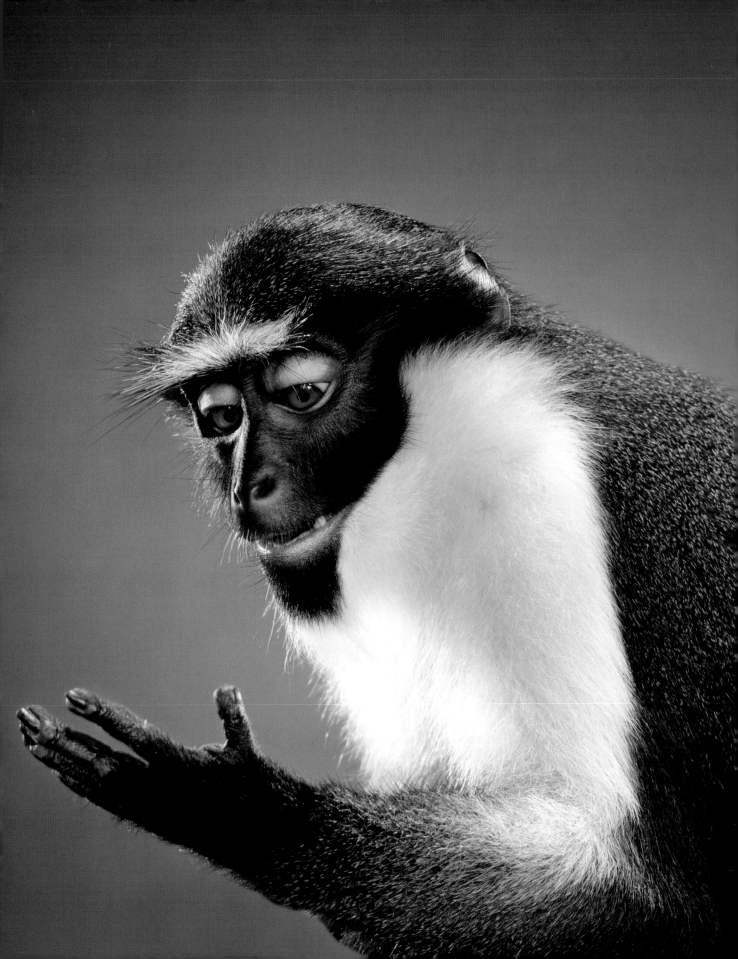

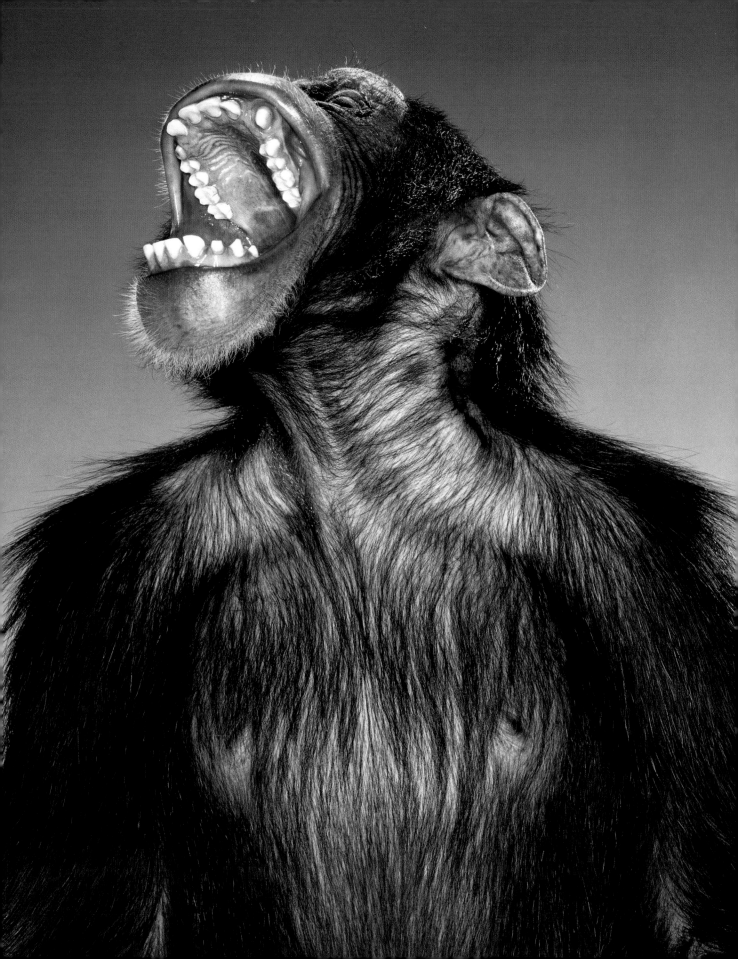

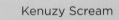

Kenuzy Scream

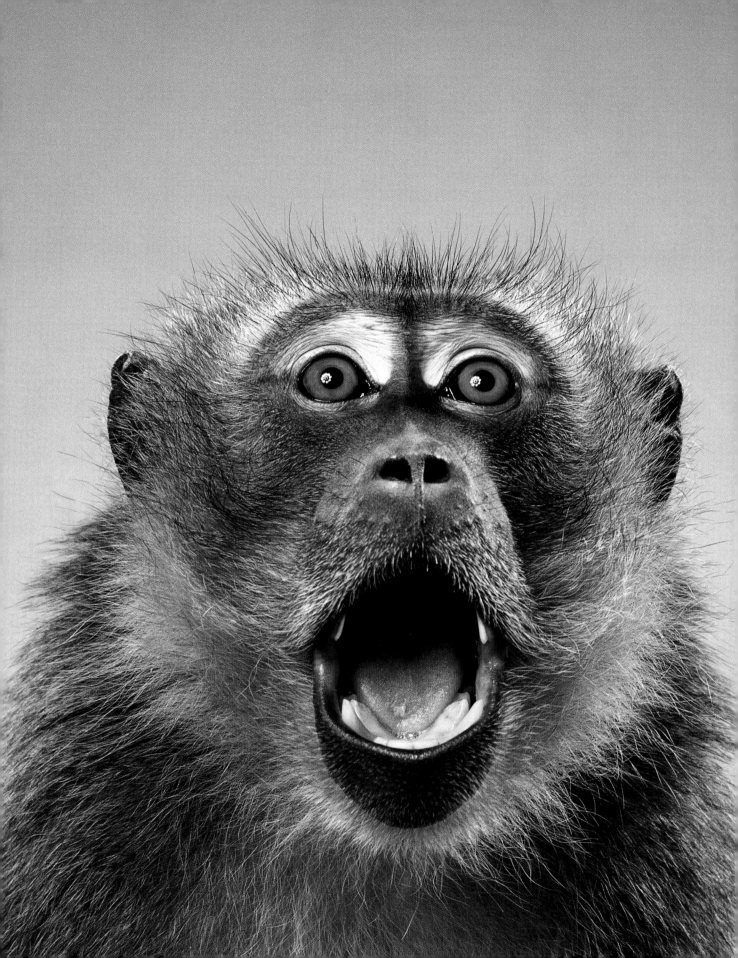

Welcome to Your Fascist Future

Little Screamer

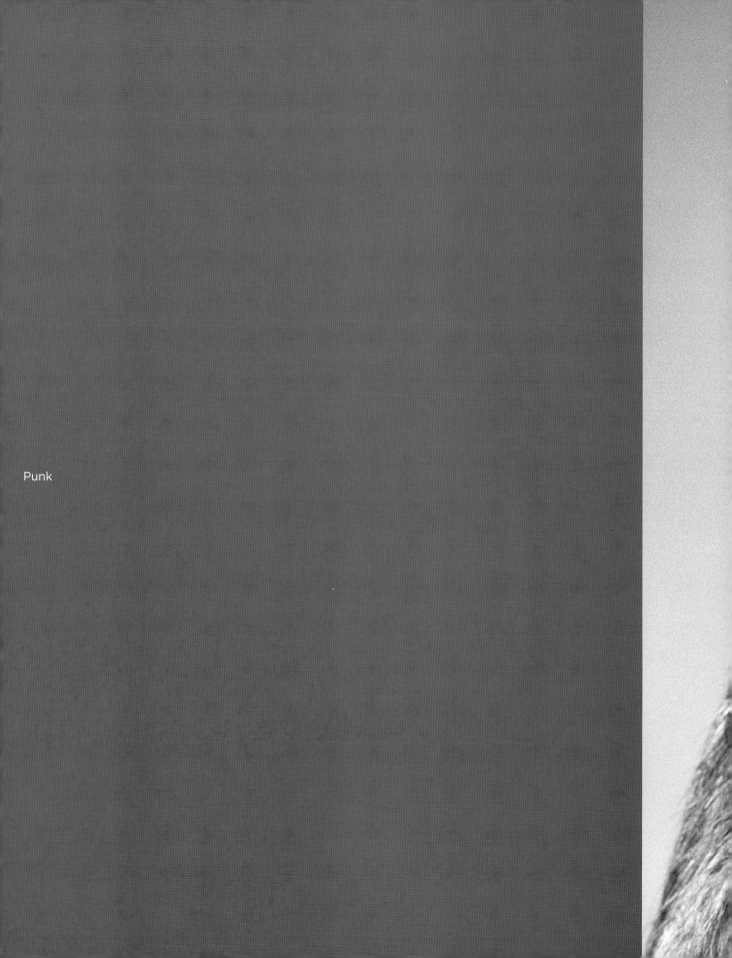

Punk

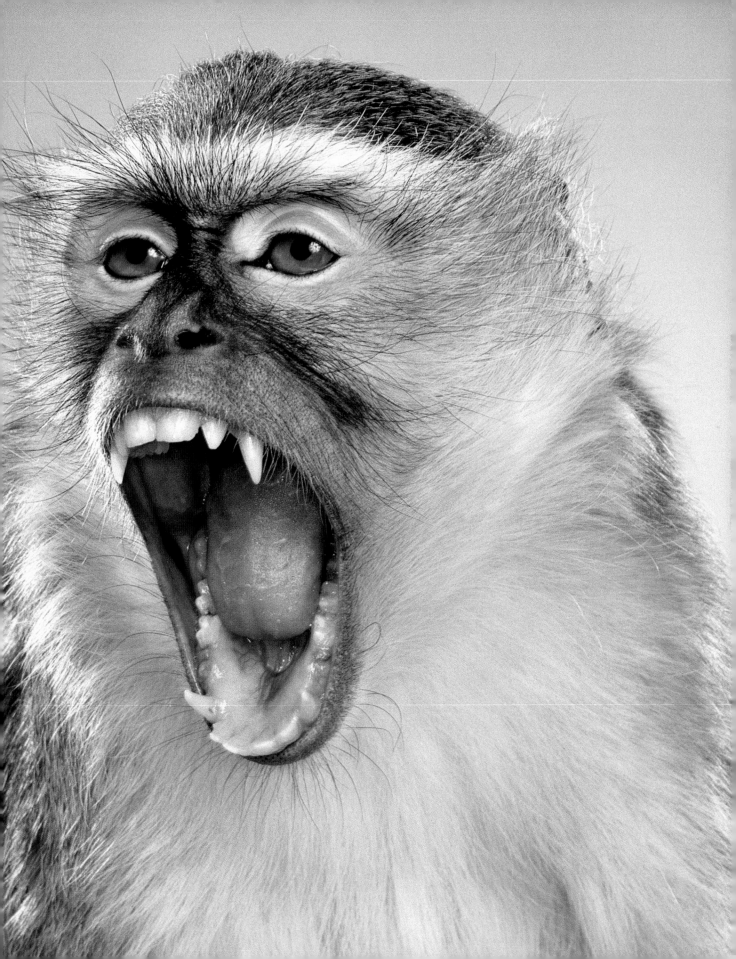

Pontificus

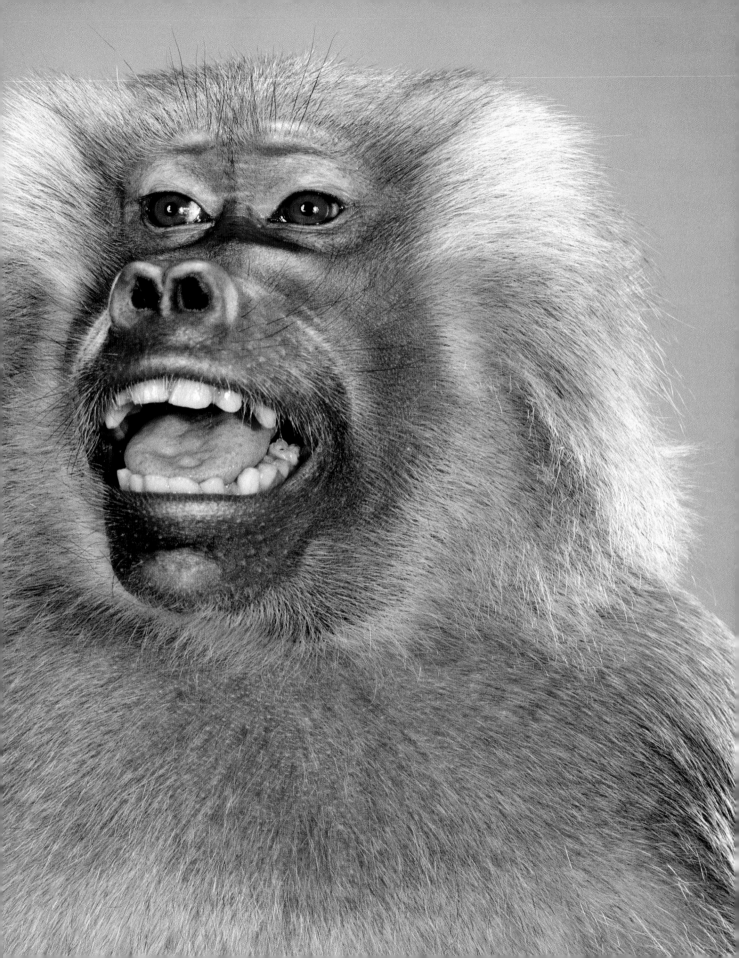

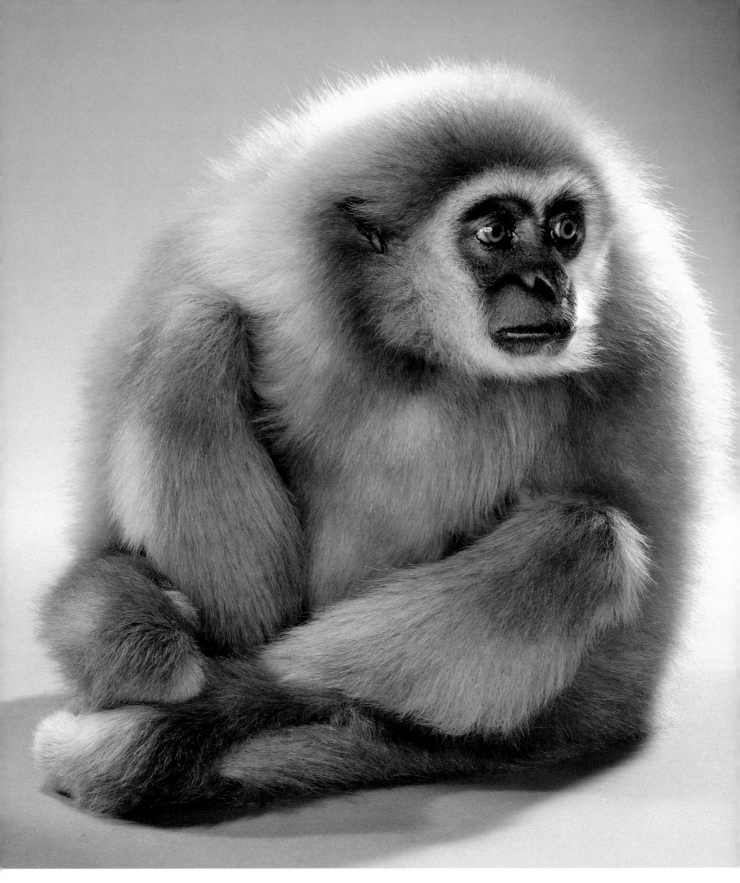

Curl

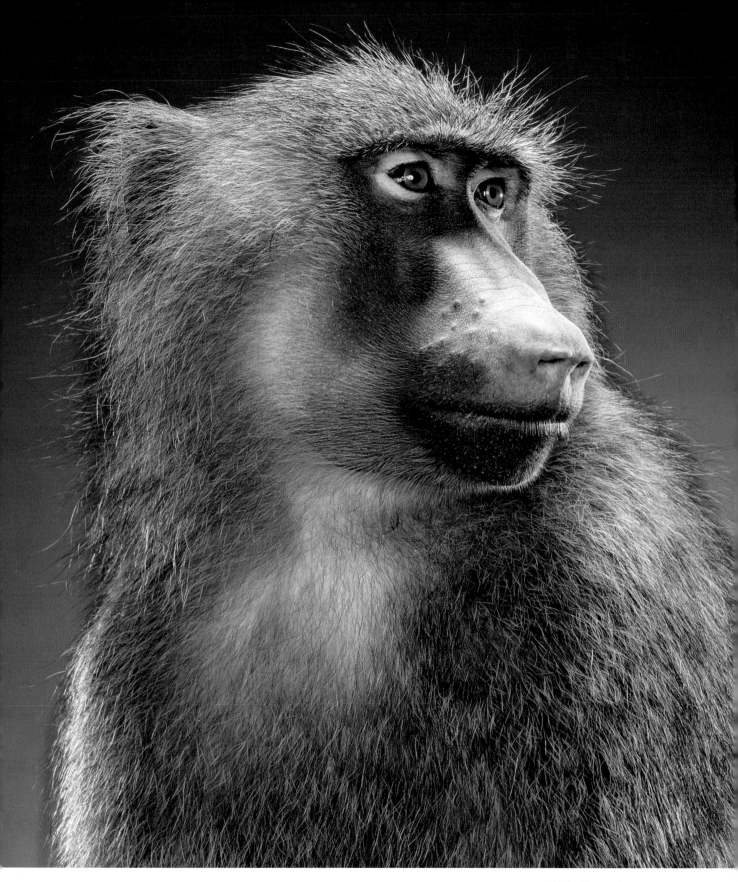

Mala Portrait

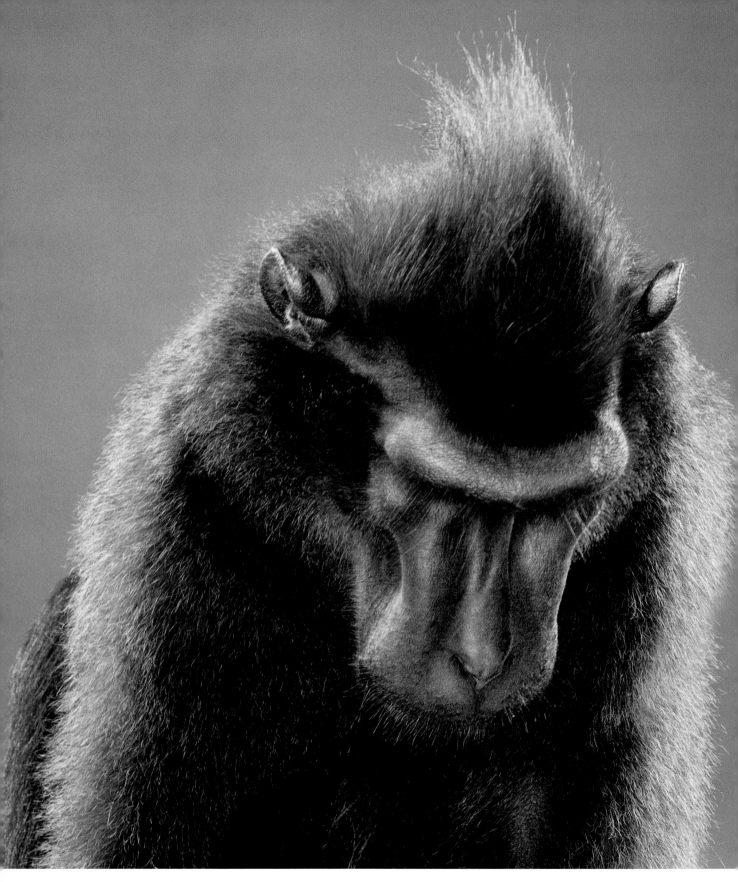

Downward

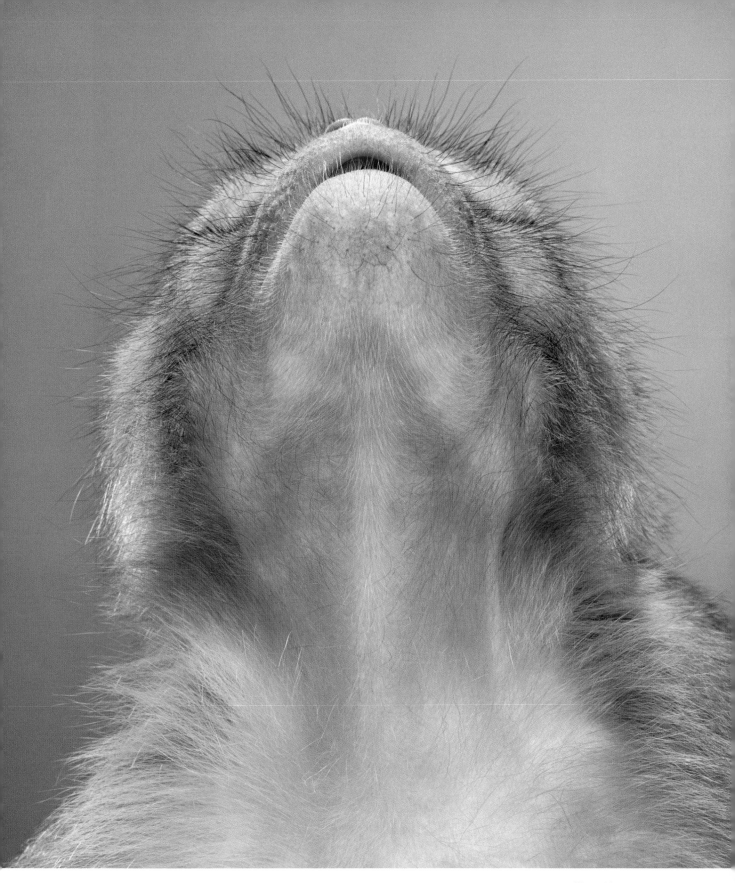

Falling Sky

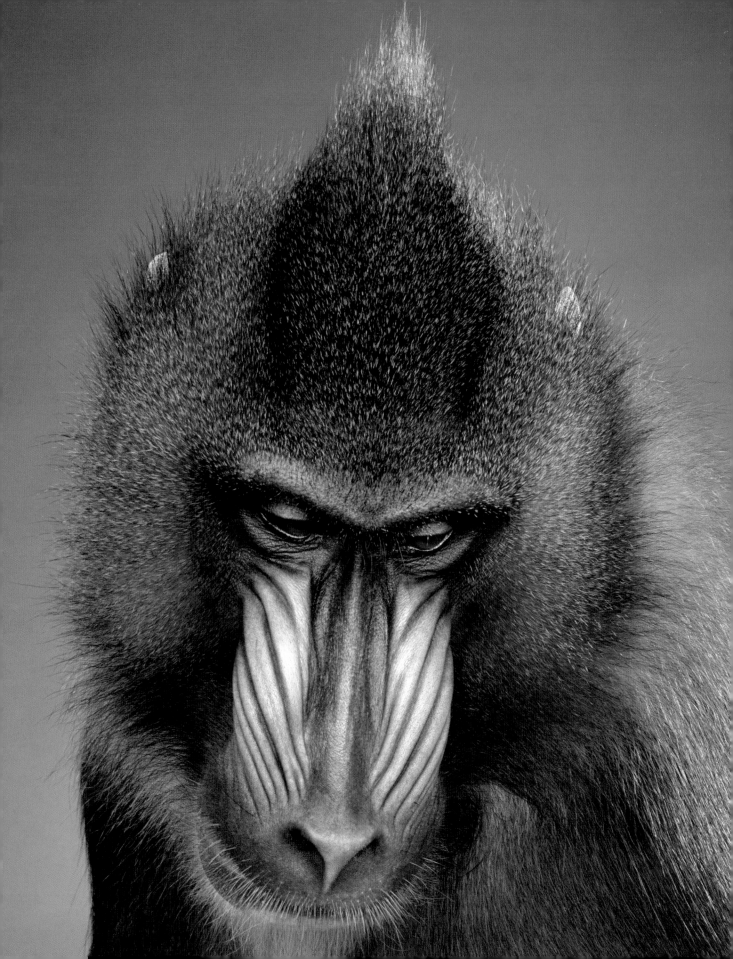

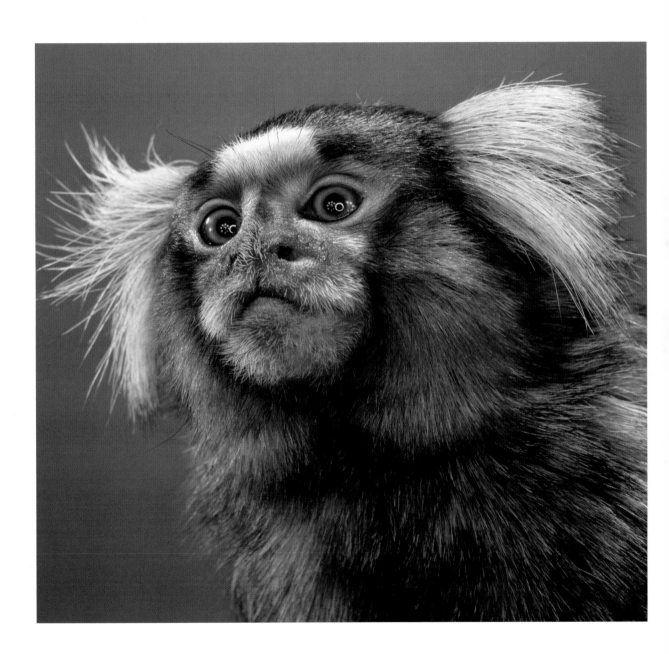

Downward Two

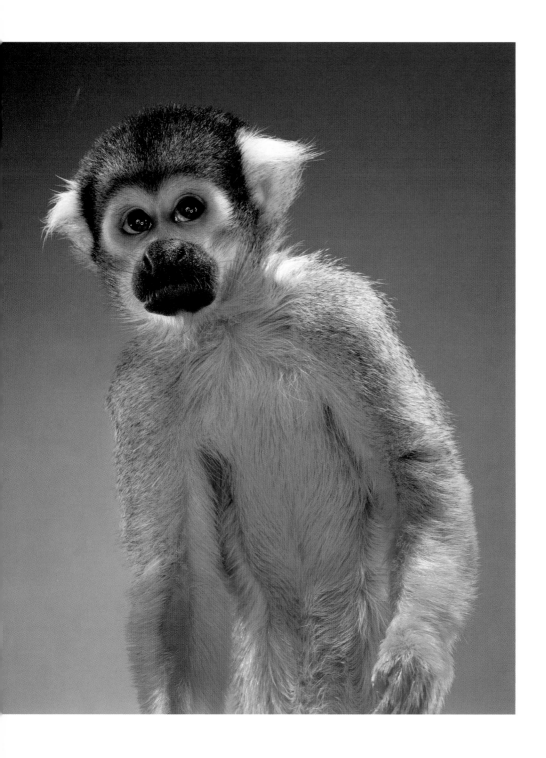

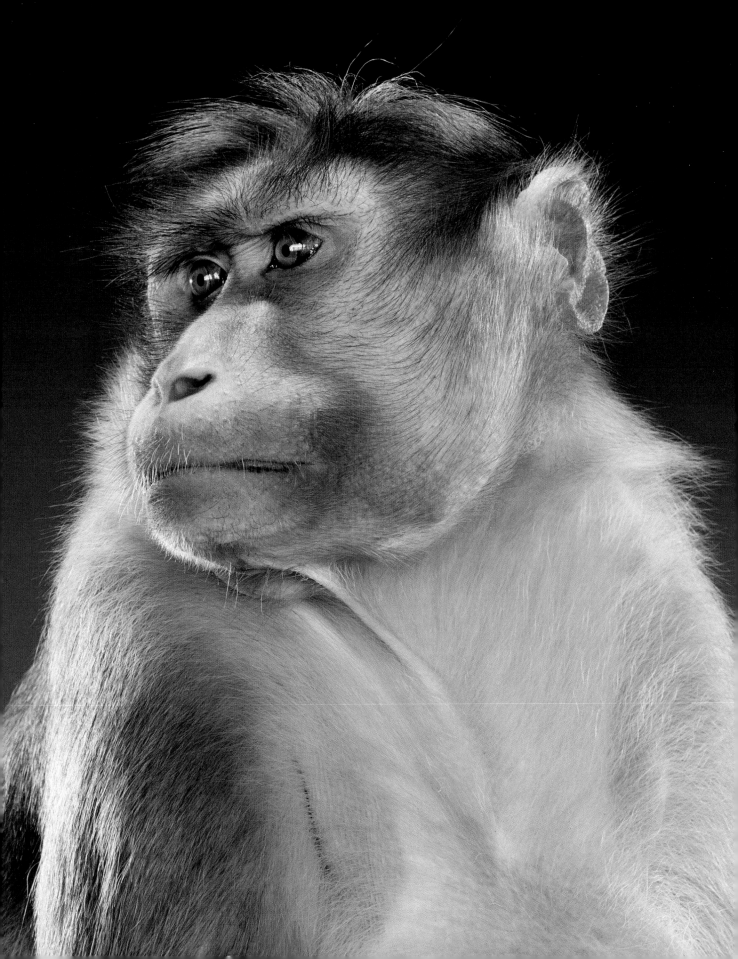

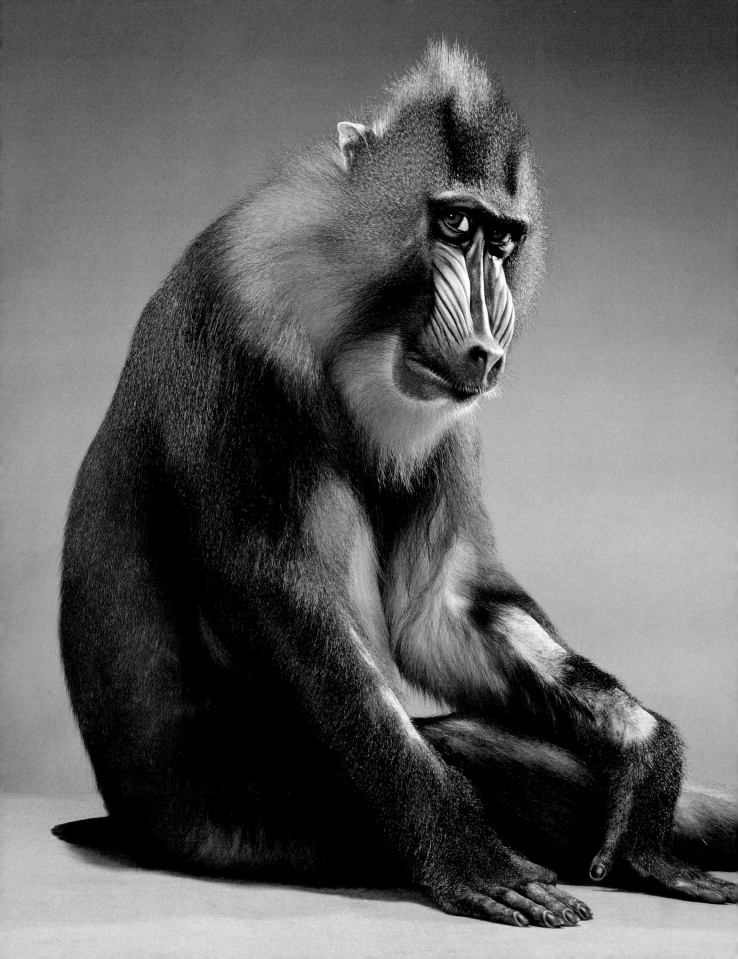

Whenever you observe an animal closely,
you feel as if a human being sitting inside were making fun of you.
ELIAS CANETTI

Oy Veh

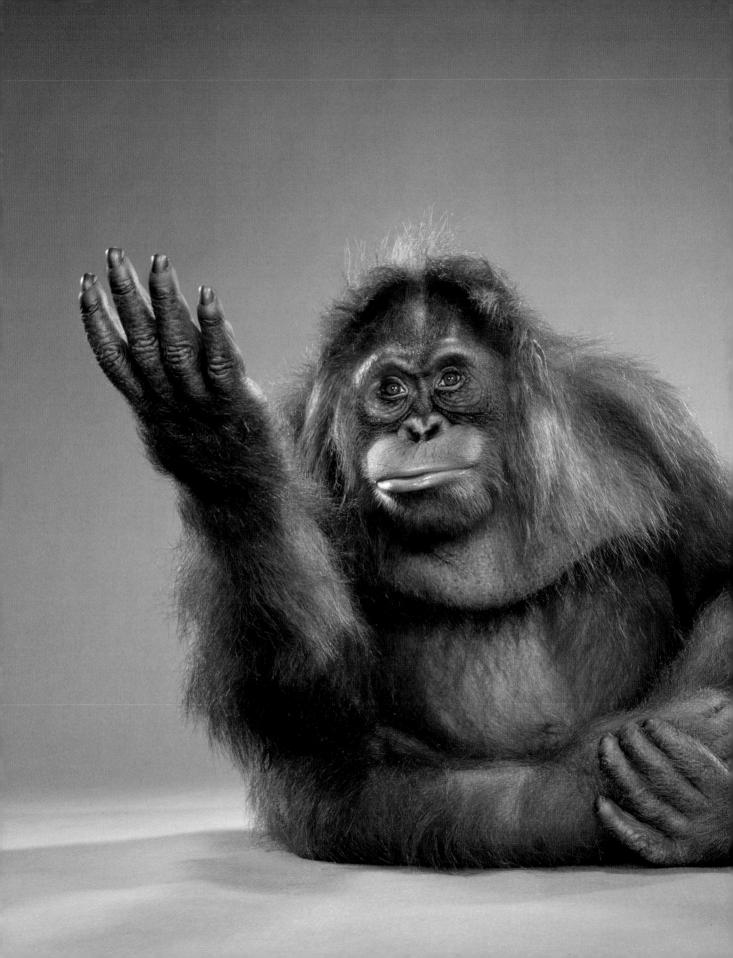

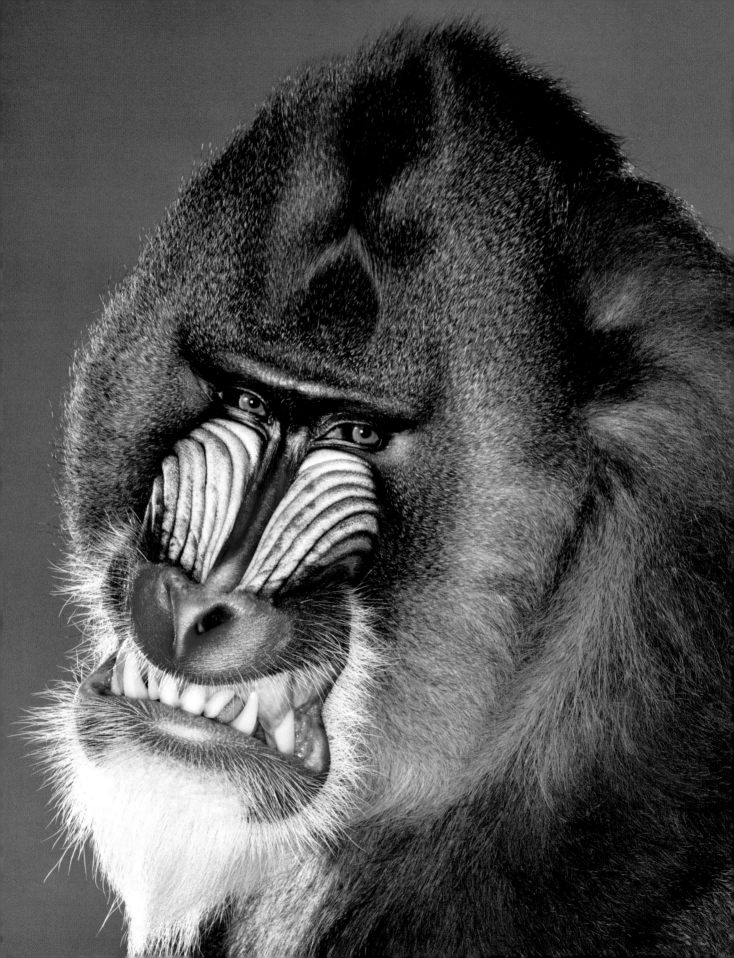

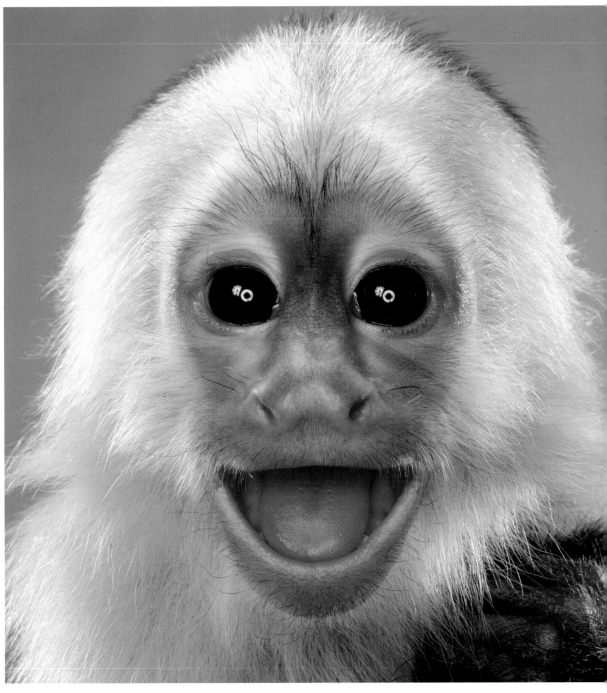

Baby Monkey

Grrr!

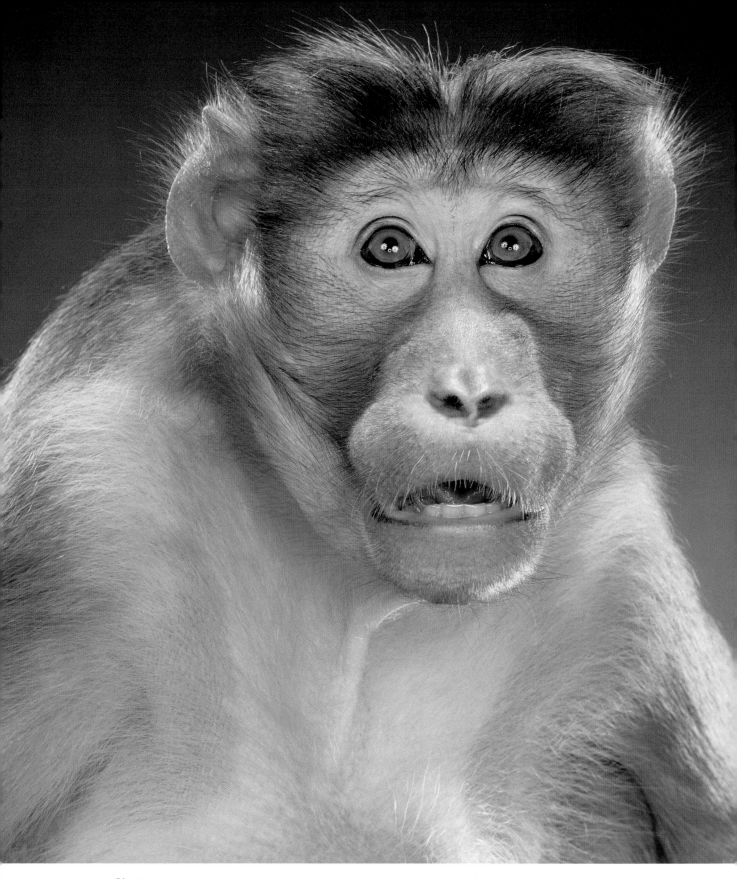

Shemp

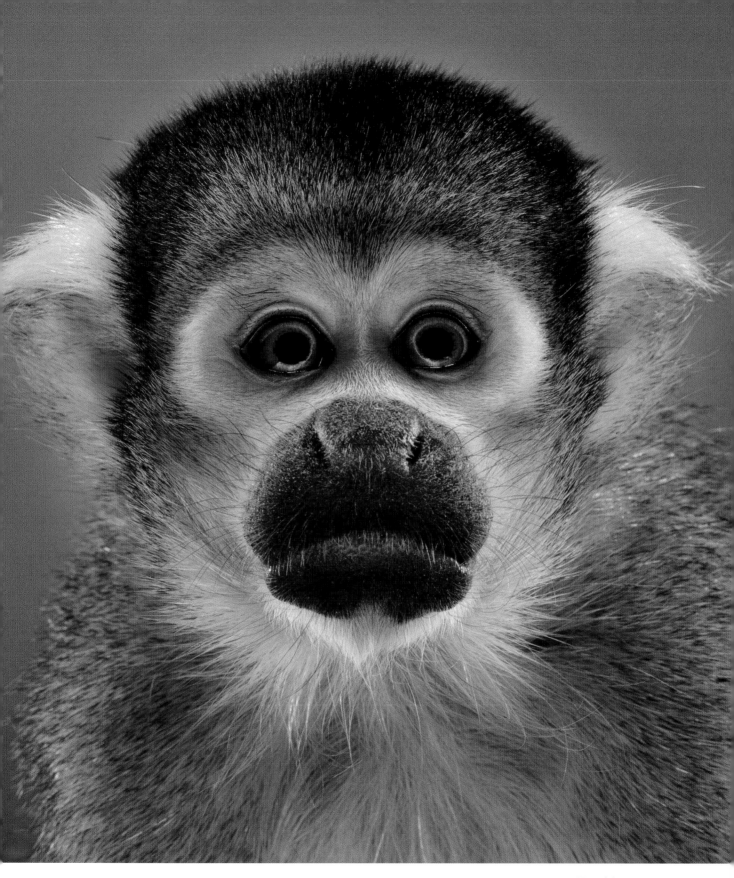

Zombie

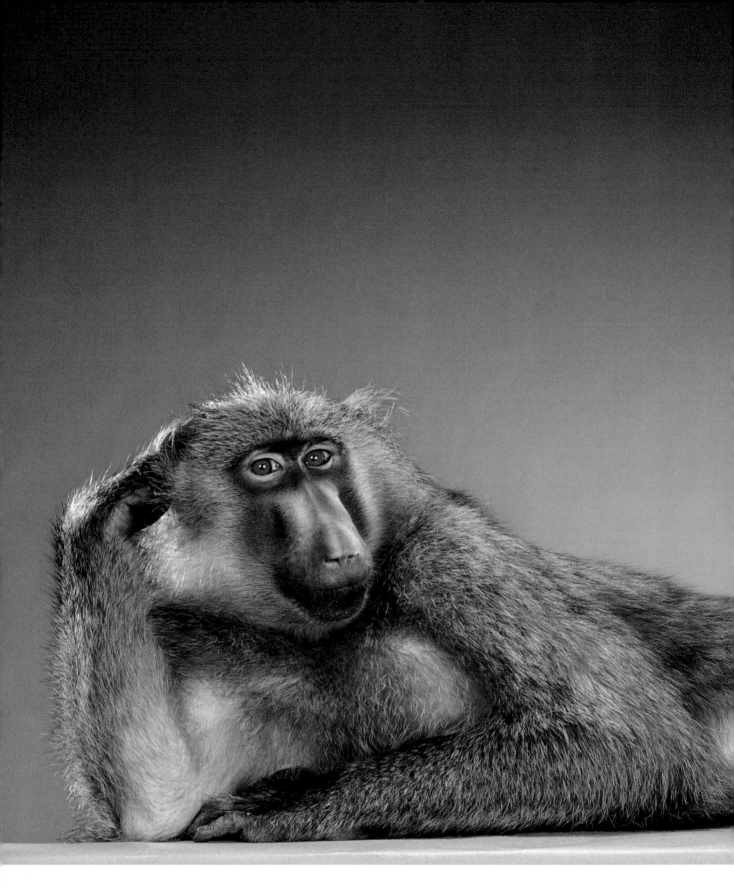

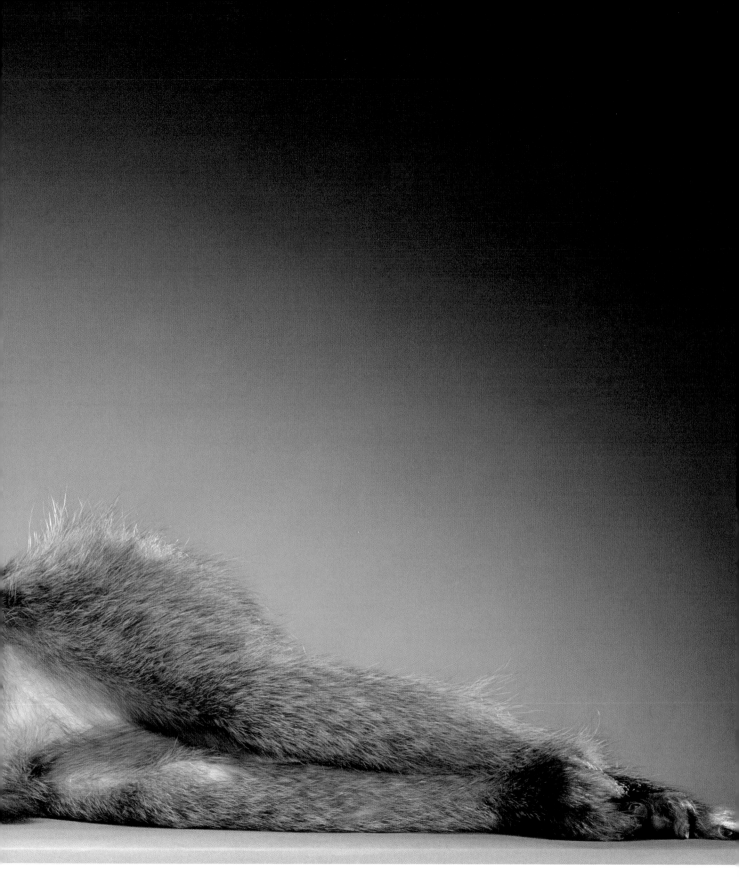

Mala Centerfold

The art of being wise is the art of knowing what to overlook.
WILLIAM JAMES

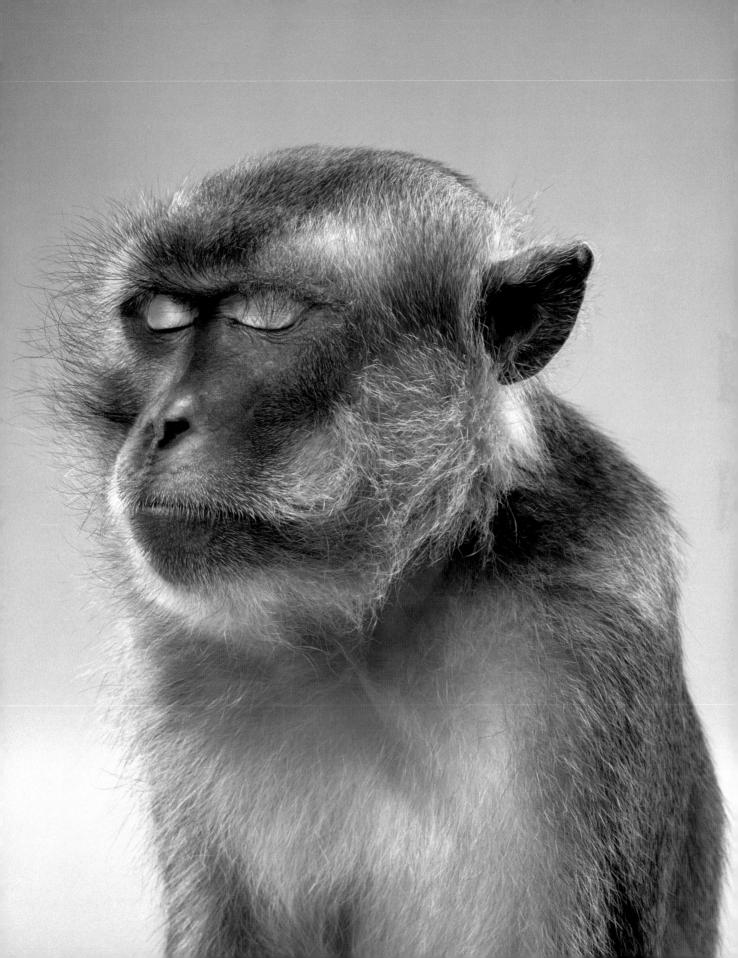

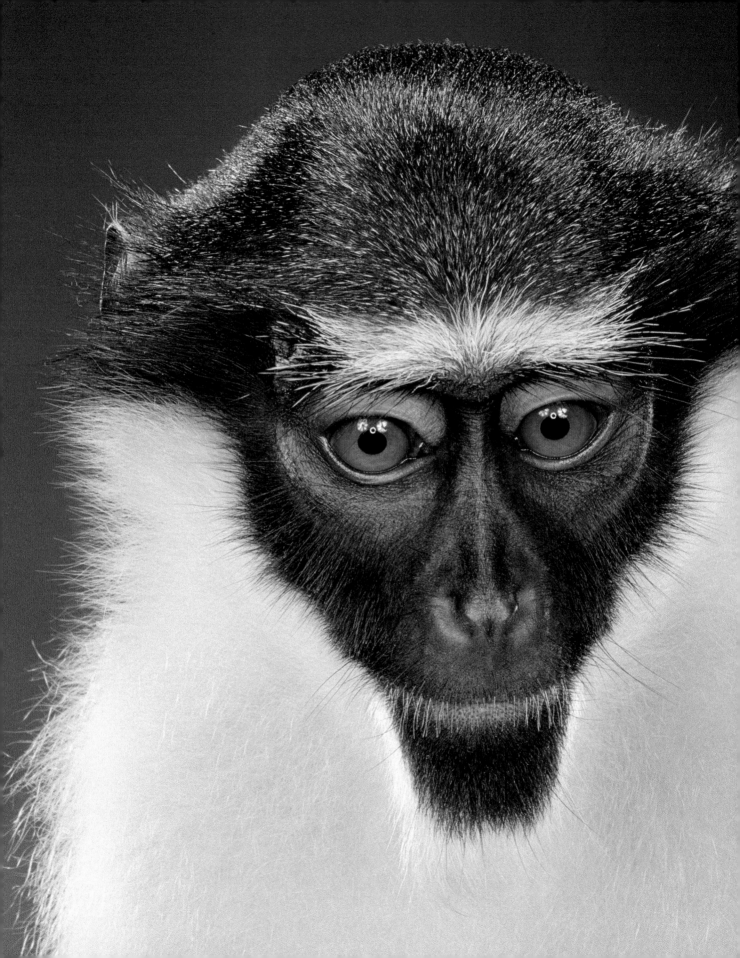

Crestfallen

Persecuted

Following: The Marmoset

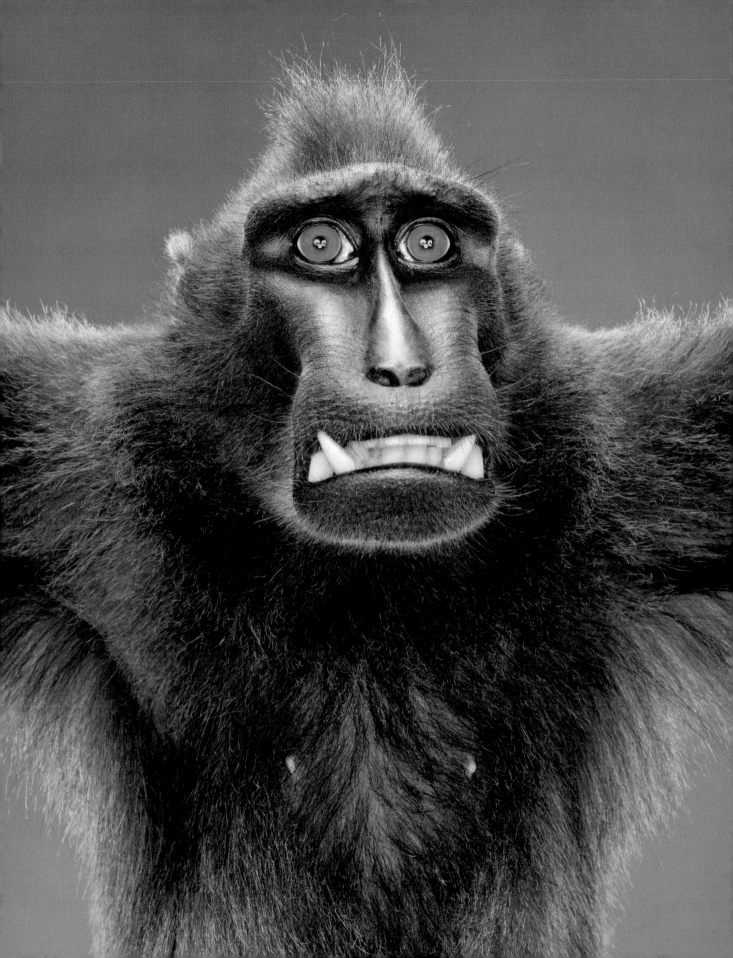

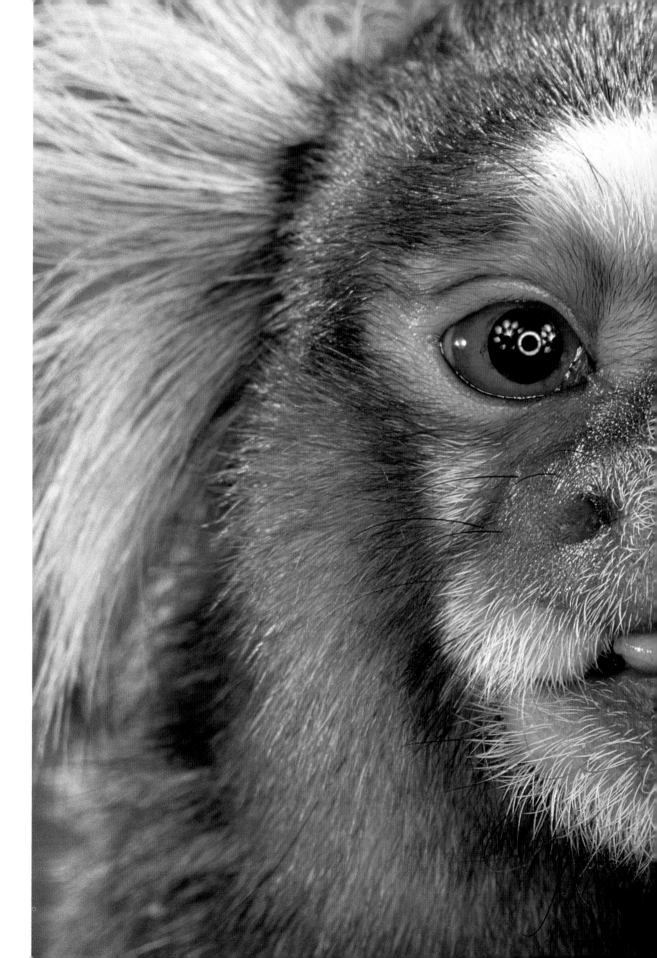

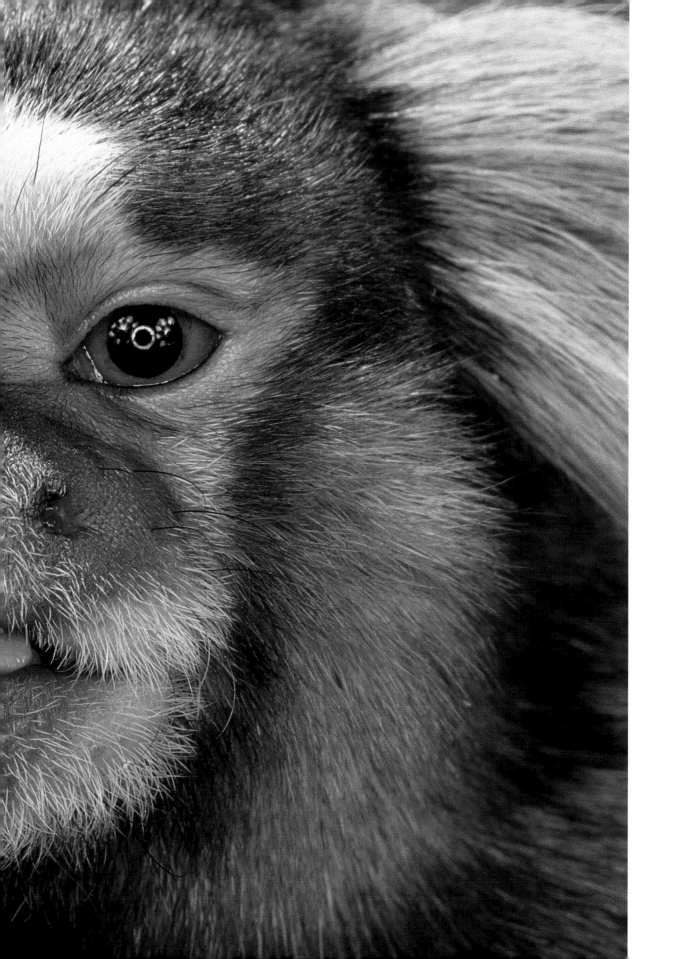

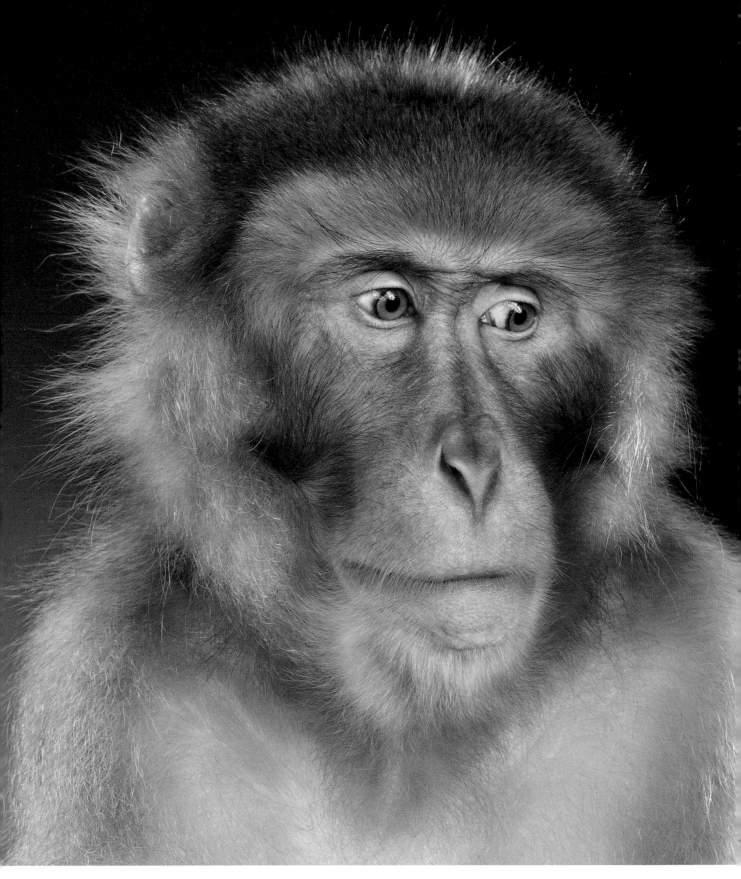

Distant

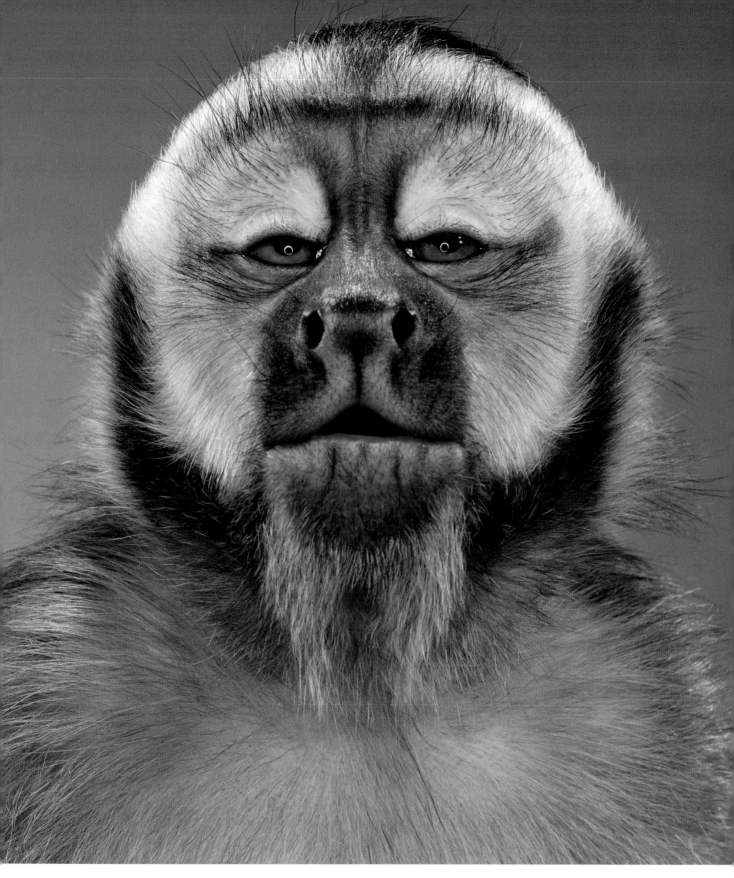

Dude

In the eye of his mother, a monkey is a gazelle.
SYRIAN PROVERB

Following pages, left to right: *Ooh!*, Porcine

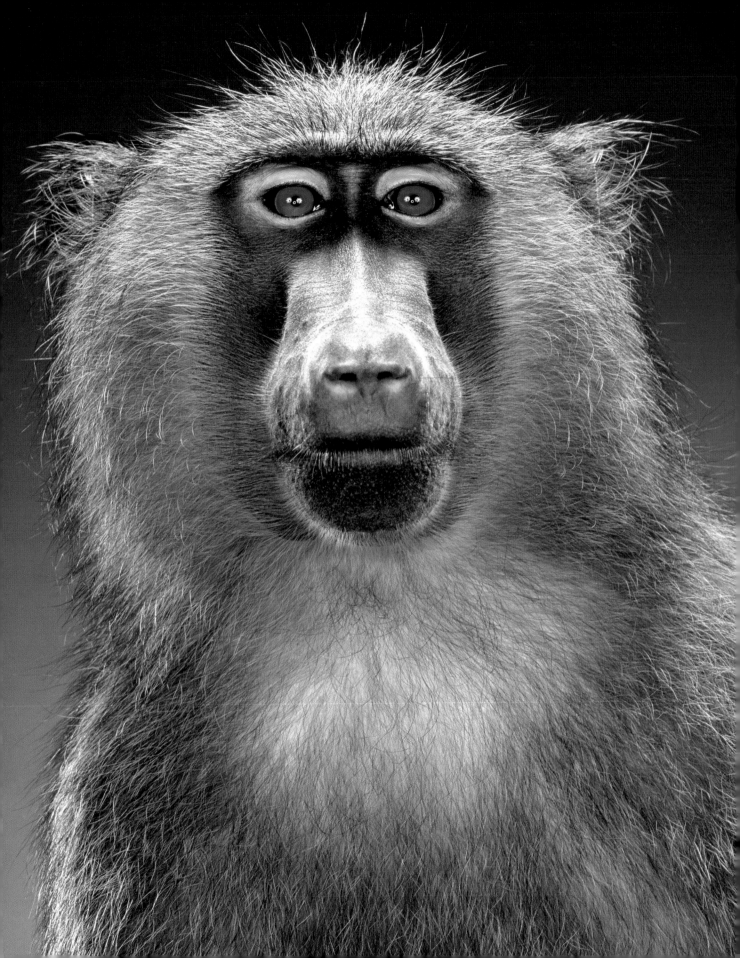

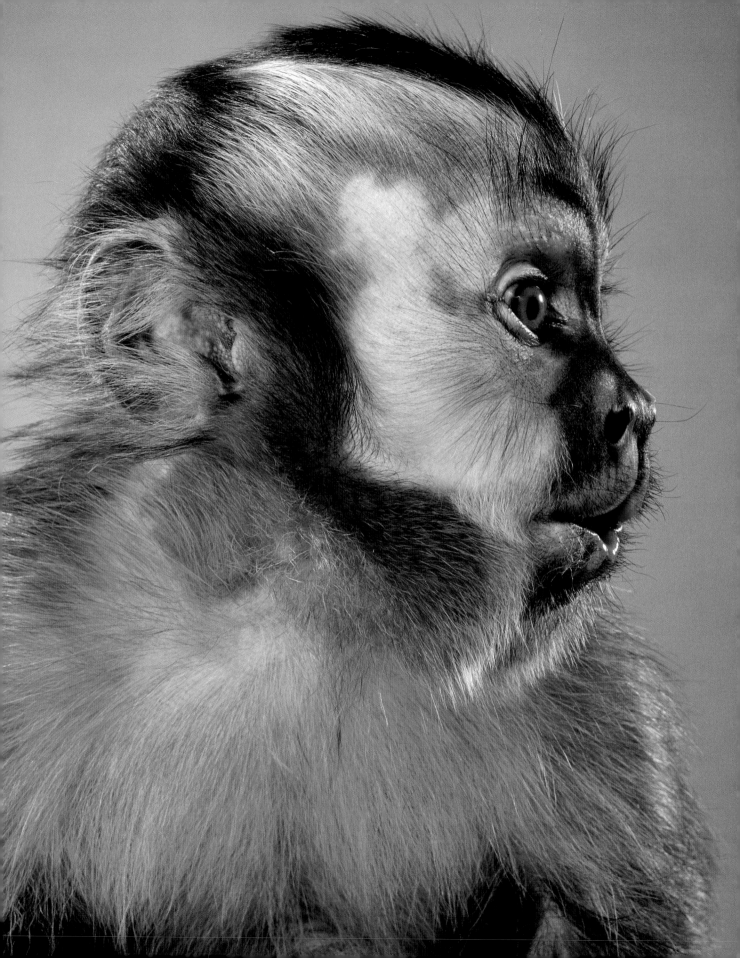

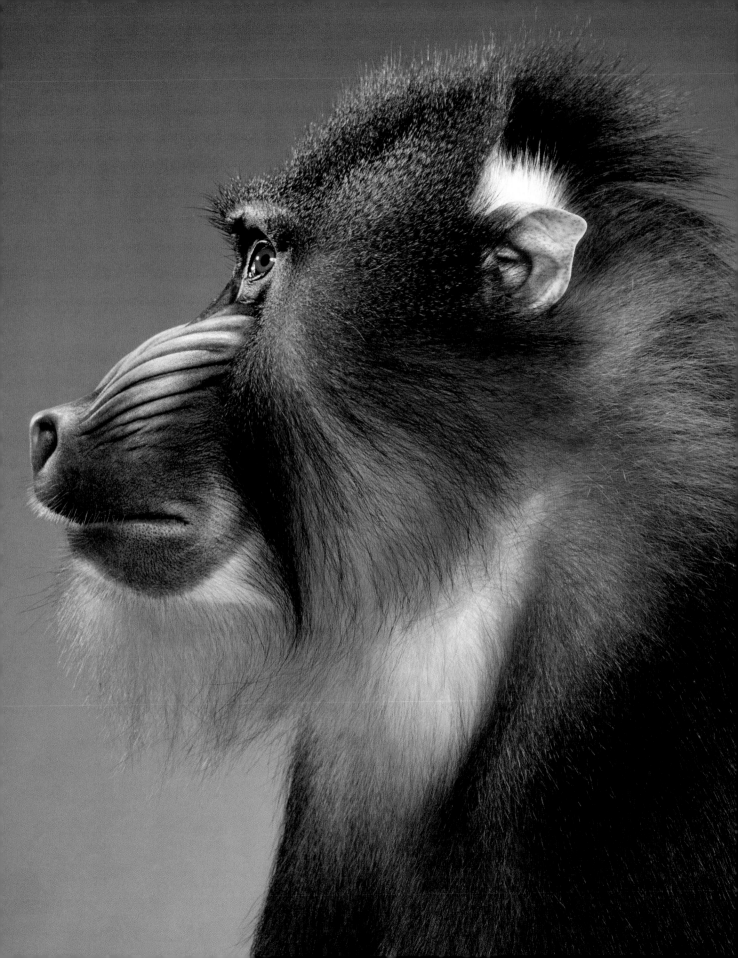

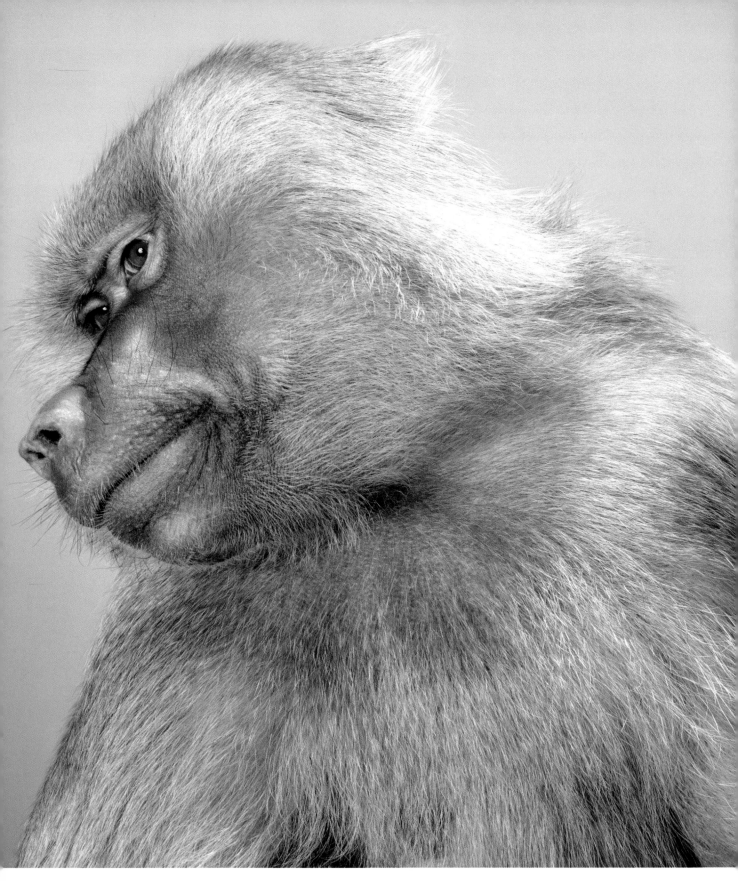

A Little to the Left

Aah!

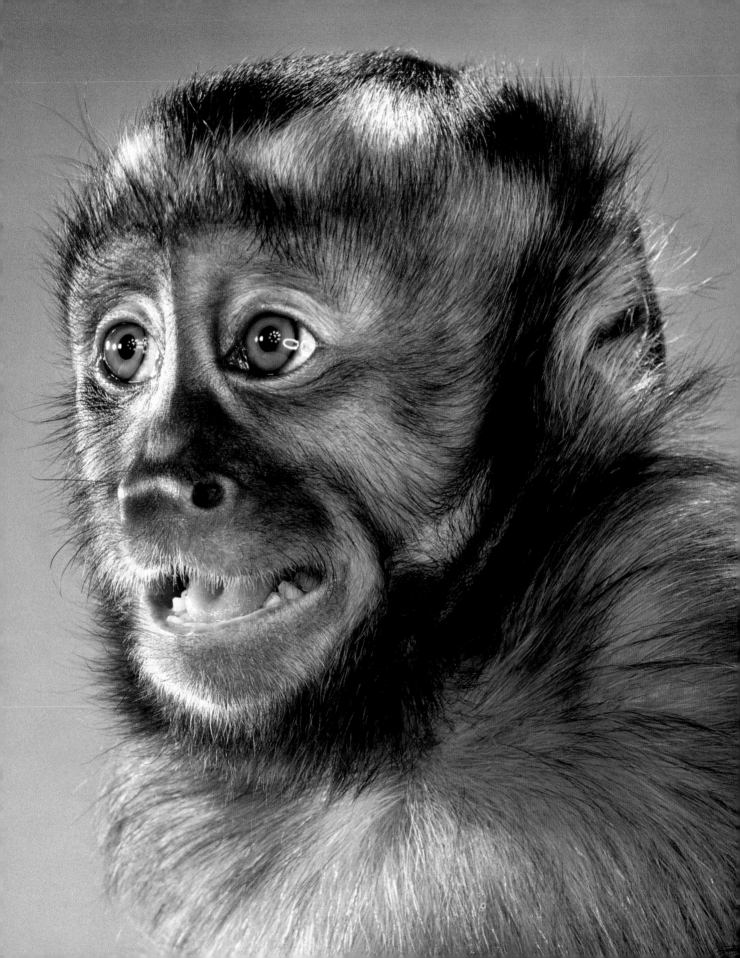

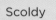Scoldy

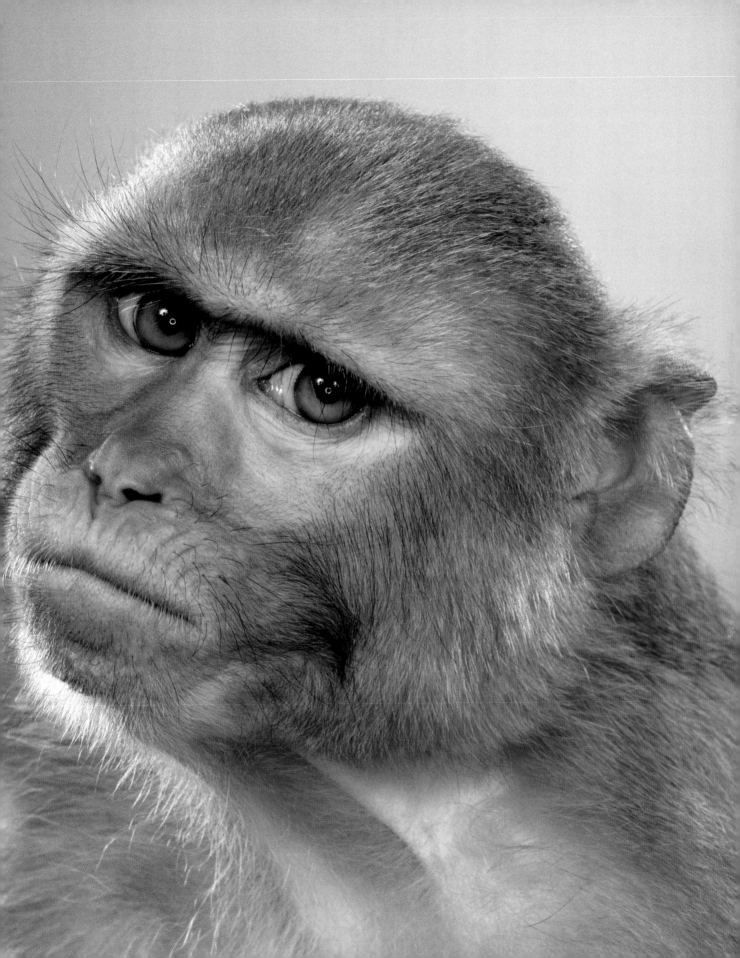

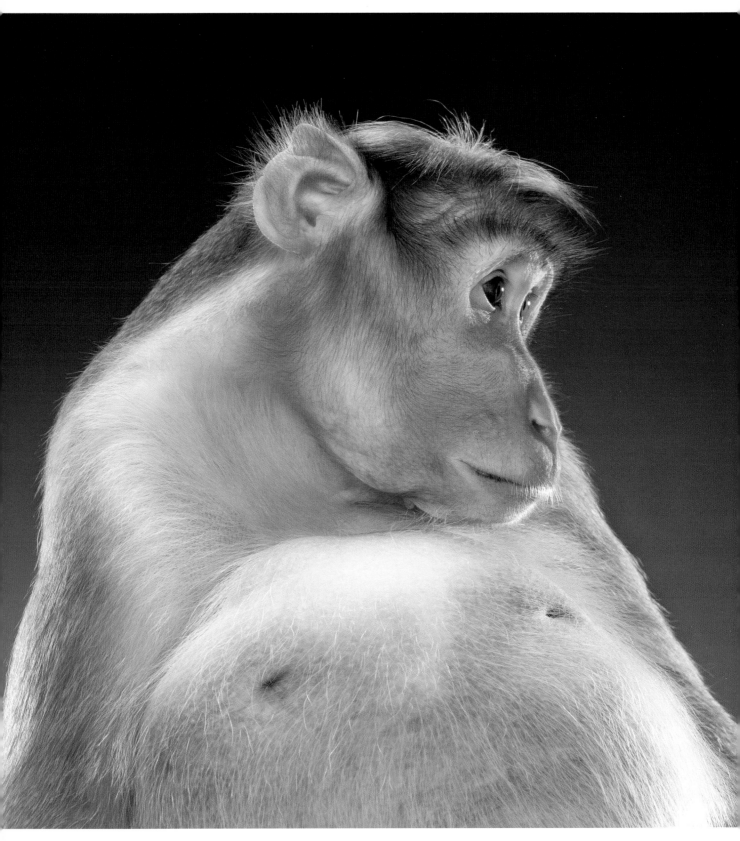

Fat Shemp

Ugly

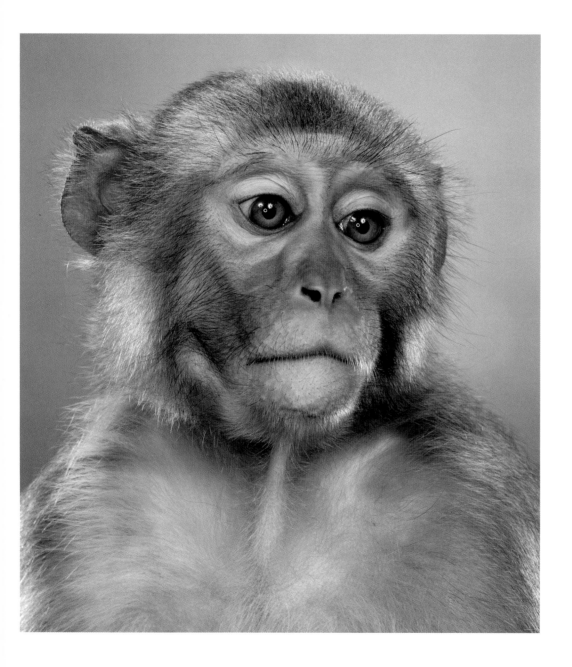

Following pages, left to right: Delirious, Wilding

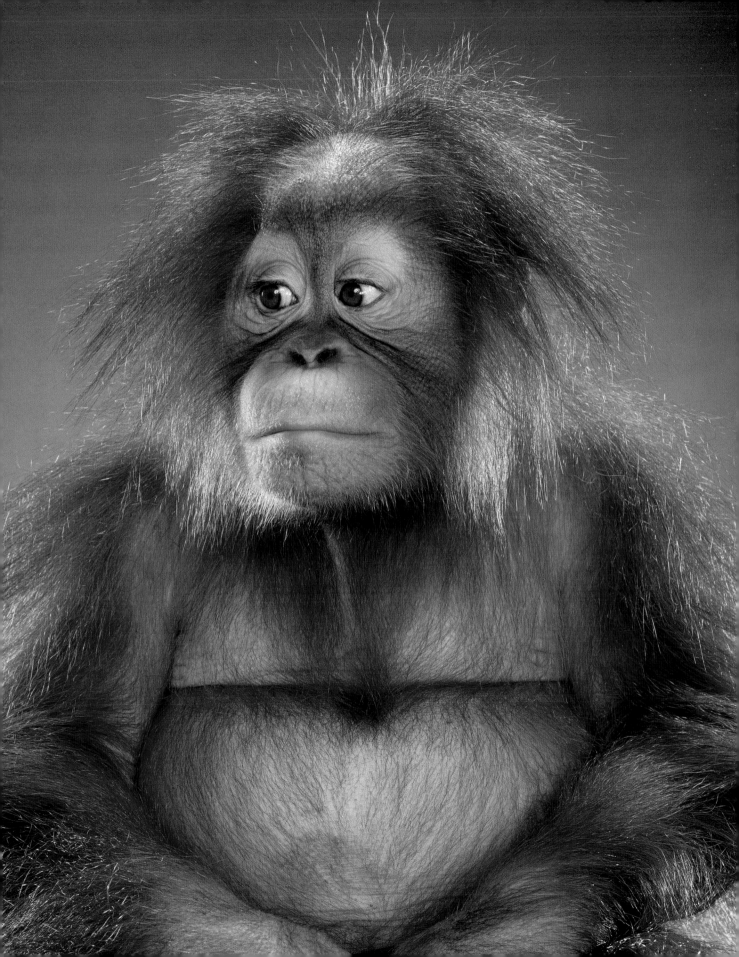

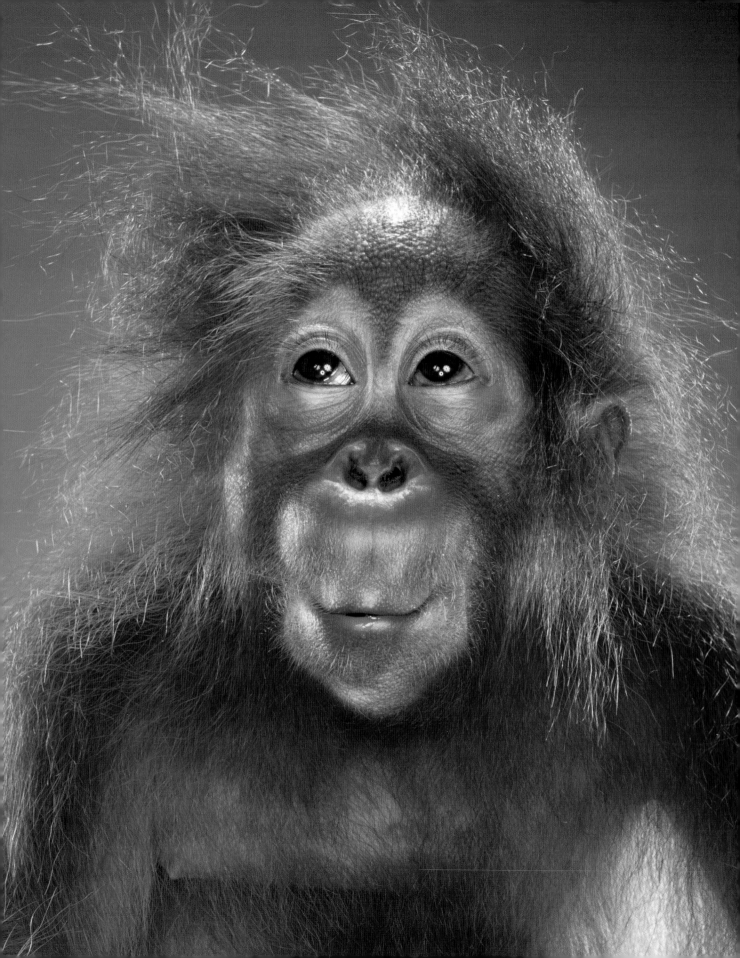

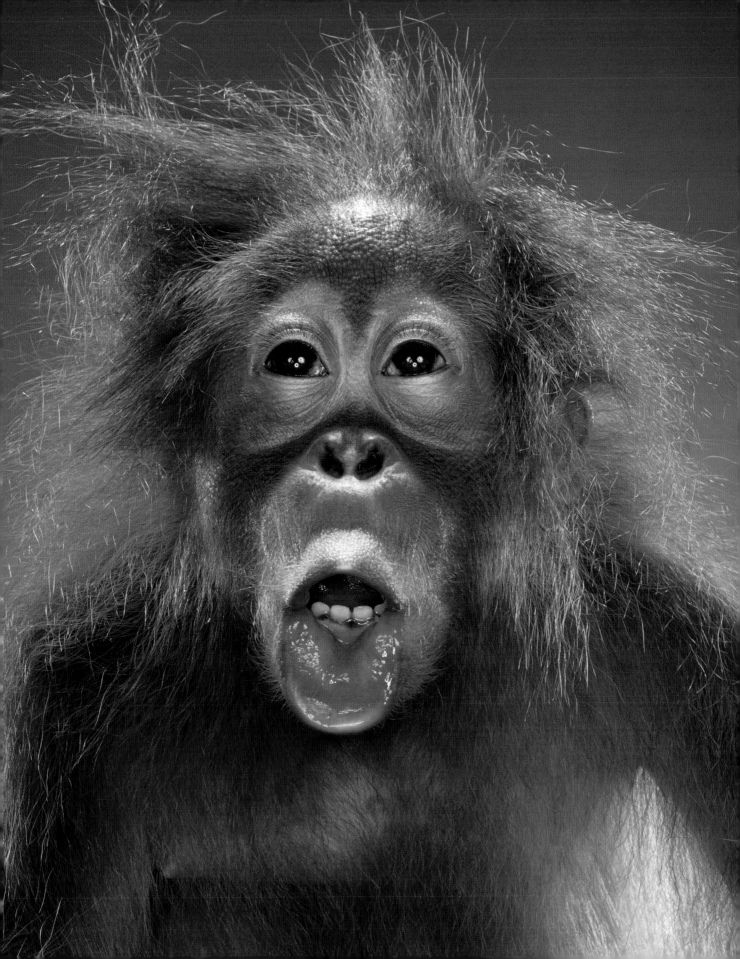

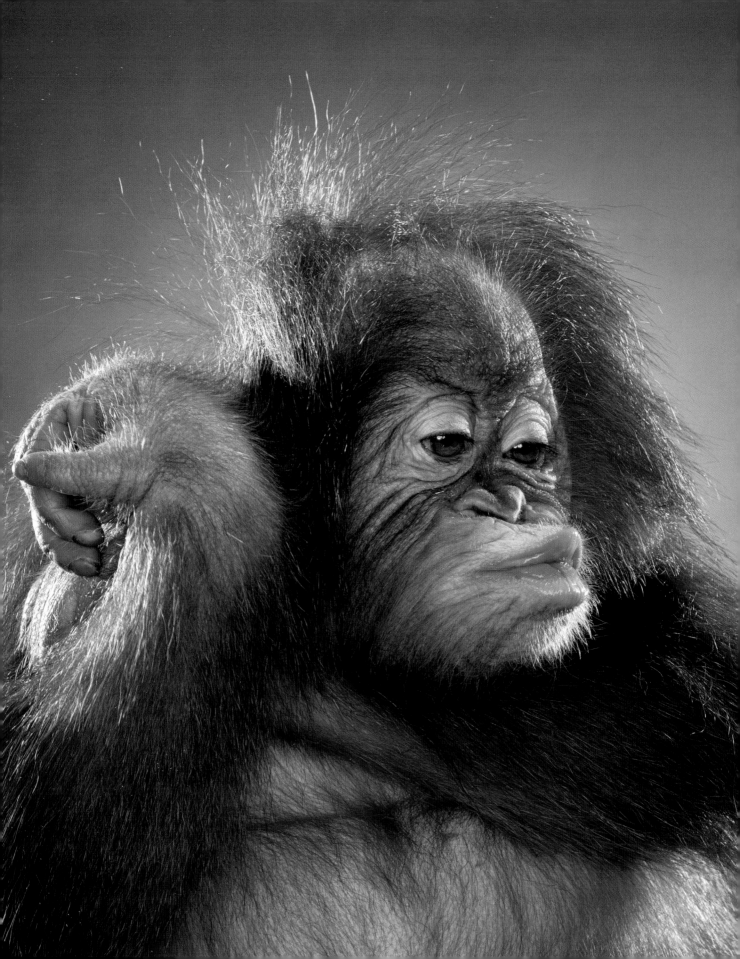

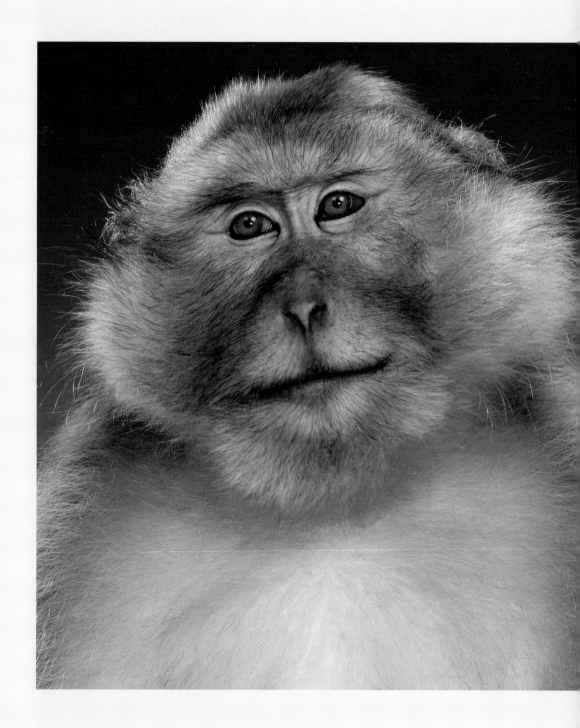

The Conundrum

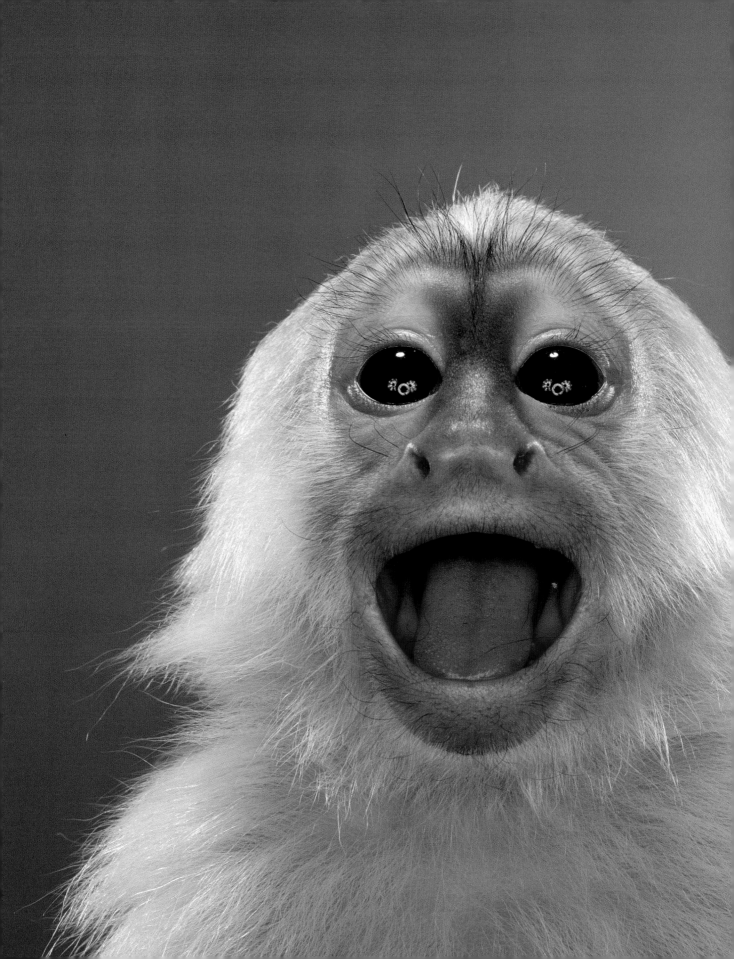

The Hatchling

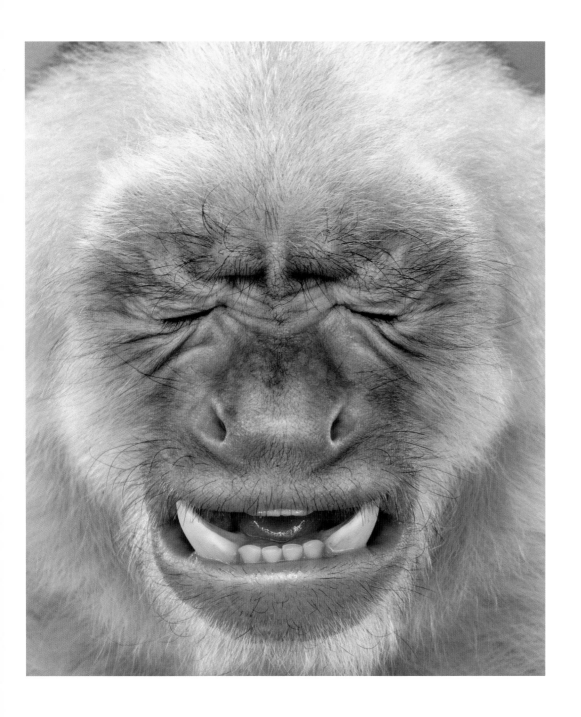

Wince Worried

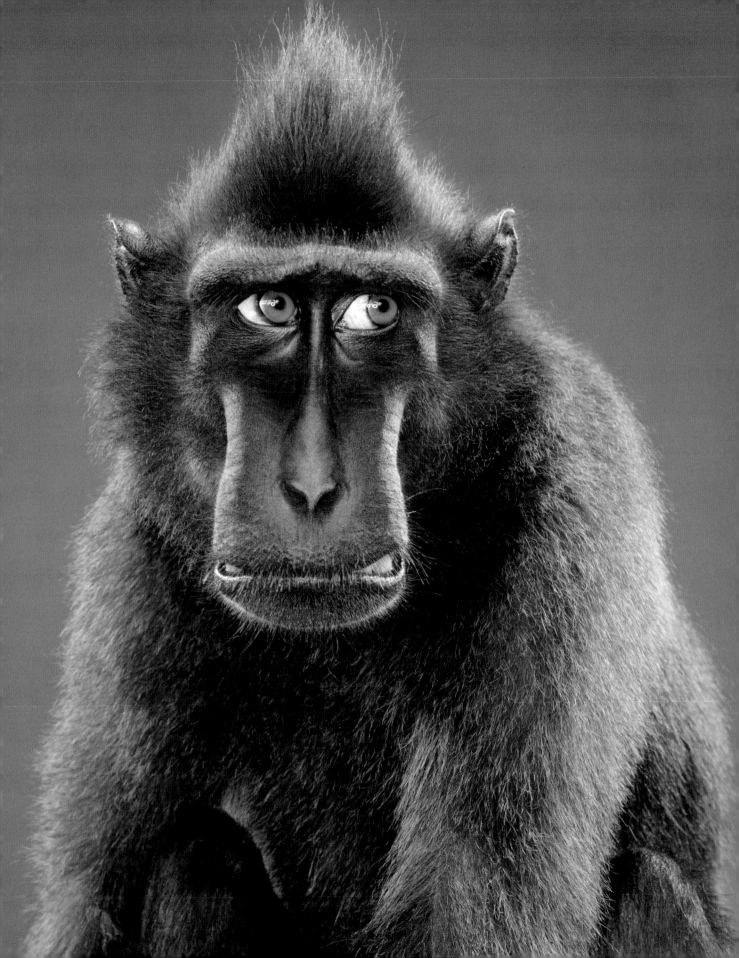

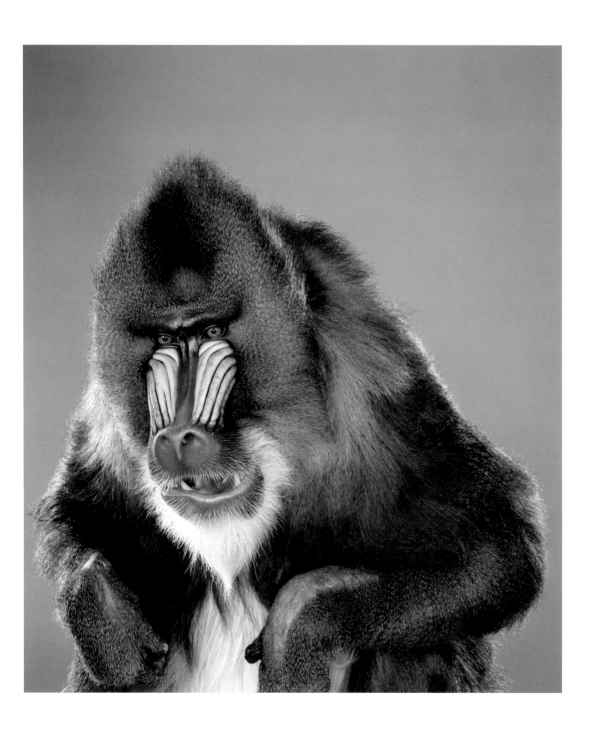

Uh-oh

Haughty

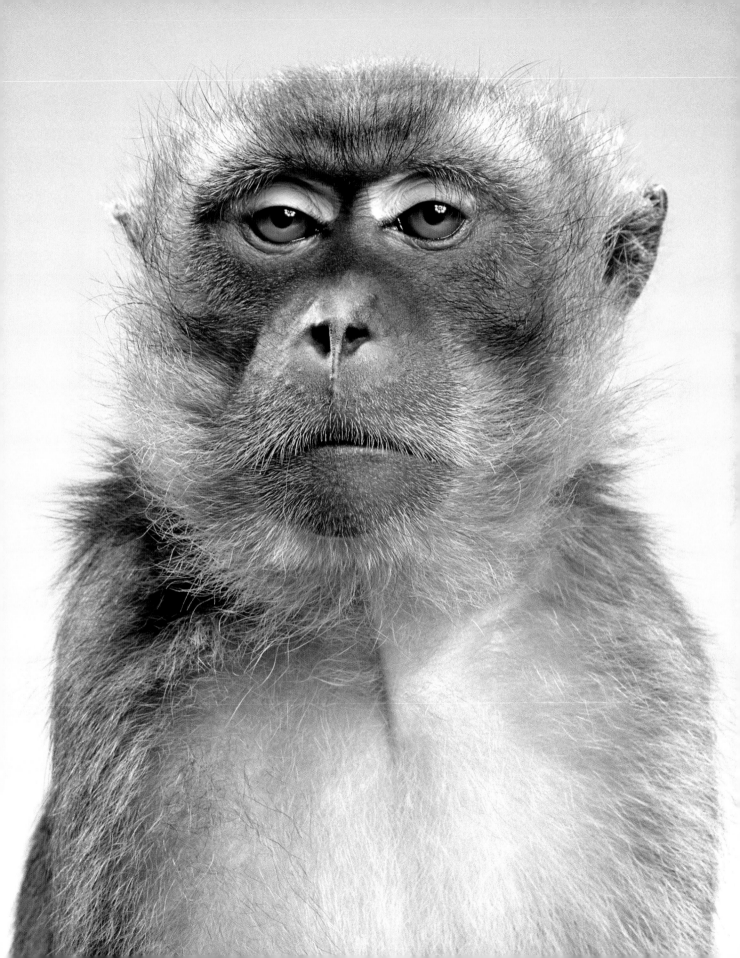

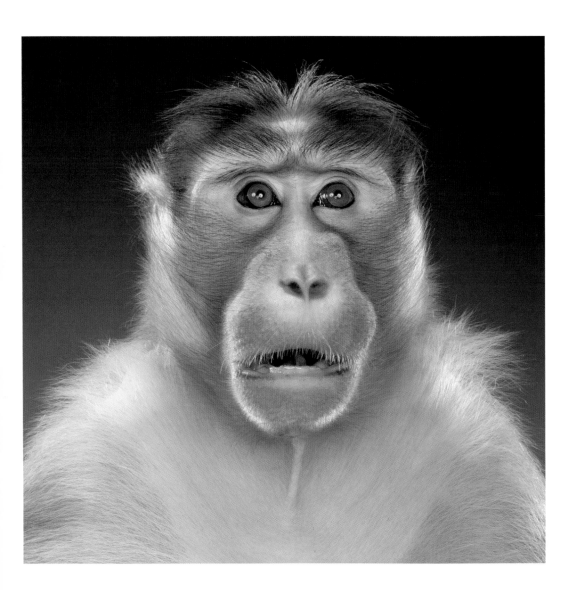

Awestruck

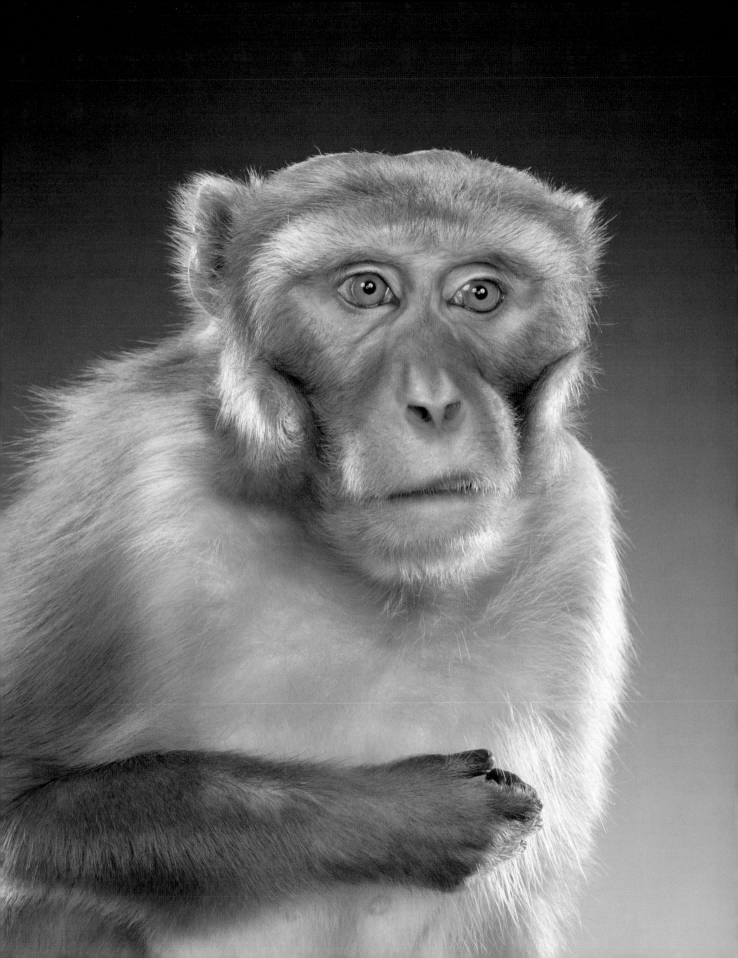

In the time of chimpanzees I was a monkey.
BECK

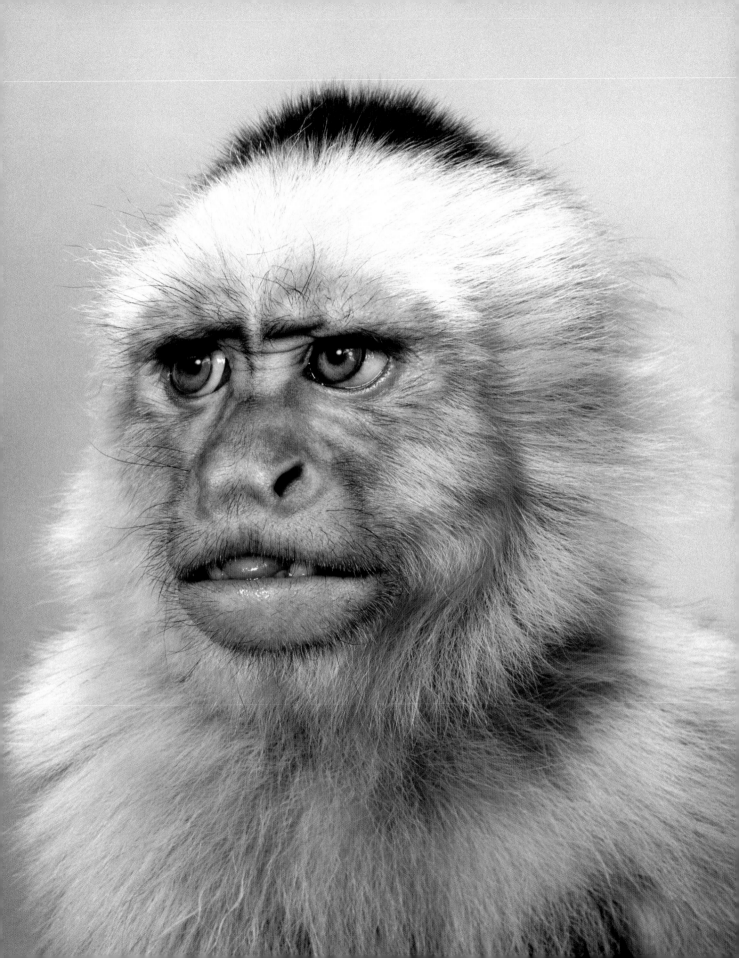

Ball of Fire

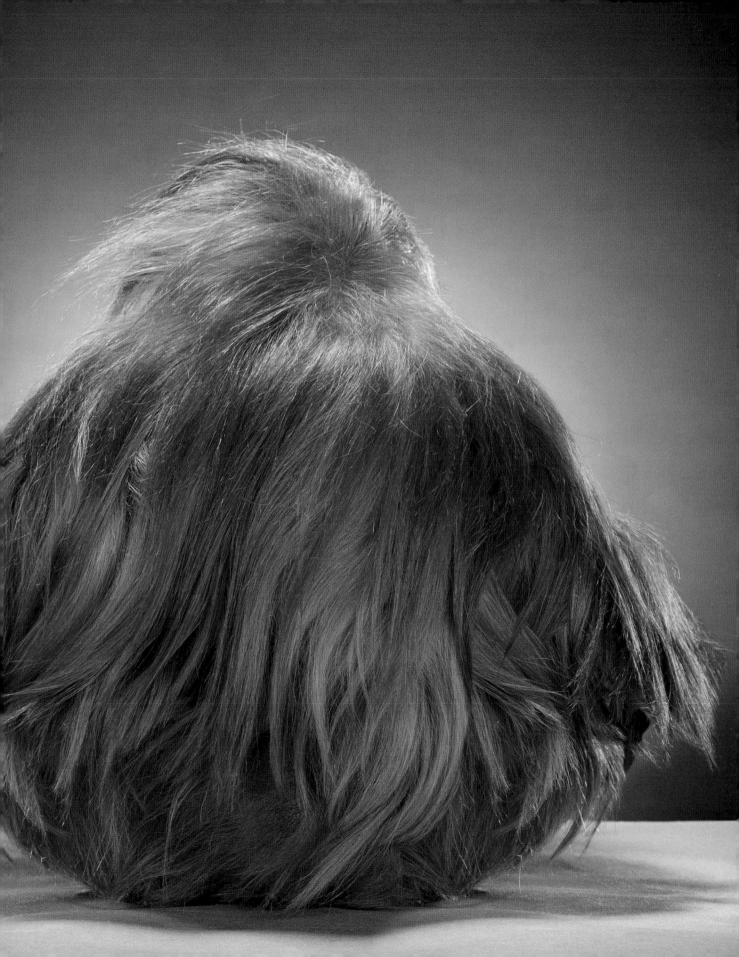

WHO'S **WHO**

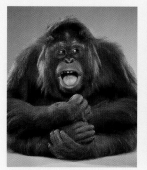

JAKE
Orangutan

Residence
Miami

Credits
King of the Jungle

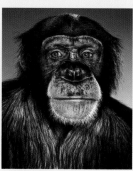

KENUZY
Chimpanzee

Residence
Los Angeles

Credits
The Animal
The Chimp Channel
Jack in the Box commercial
MCI commercial
PG Tips tea commercial
Sunny Delight commercial
Toyota Prius commercial

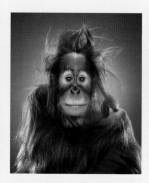

ROCKY
Orangutan

Residence
Los Angeles

Credits
Maxim magazine

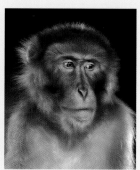

CHUBAKA
Japanese Snow Macaque

Residence
Miami

Credits
Ace Ventura: Pet Detective
The Jungle Book
The Road to Wellville
Carriers

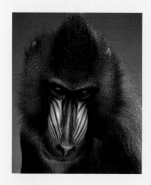

KONGO
Mandrill

Residence
Miami

Credits
Schweppes commercial

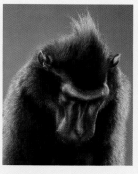

JOSH
Celebese Macaque

Residence
Upstate New York

Credits
Jack Hanna's Animal Adventures
Late Night with Conan O'Brien
The Maury Povitch Show
Black and Decker commerical

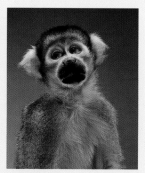

BAMBOO
Squirrel Monkey

Residence
Los Angeles

Credits
The Tonight Show with Jay Leno
Burger King commercial
Xerox commercial
Student films

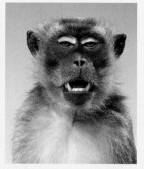

MOE
Java Macaque

Residence
Los Angeles

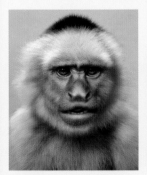

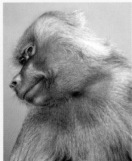

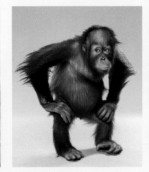

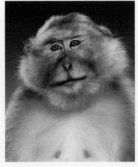

KATIE
Capuchin

Residence
Los Angeles

Credits
Bruce Almighty
King Cobra
Friends
Excedrin commercial
Pepsi commercial

GEORGIA
Hamadryas Baboon

Residence
Monterey, CA

Credits
Born Free
The Lion King
Many national commercials

BAMBAM
Orangutan

Residence
Los Angeles

Credits
The Bold and the Beautiful
Passions
Rynkeby Juice

SALLY
Macaque

Residence
Westown, New York

Credits
Rescue Me
The Sally Jesse Raphael Show
Black & Decker commerical
Daisy Fuentes photo shoot
Martha Stewart Kids

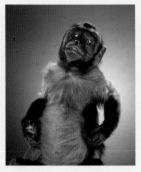

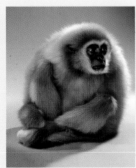

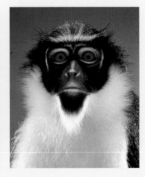

DAX
Black Capped Capuchin

Residence
New York

Credits
The Howard Stern Show
The View
Greeting cards
Private parties

GABE
Gibbon

Residence
Los Angeles

Credits
The Jungle Book

AZUMAH
Mandrill

Residence
San Francisco

LOLA
Diana Monkey

Residence
Miami

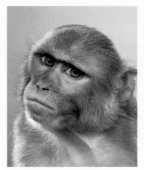

ASIA
Rhesus Macaque

Residence
Los Angeles

Credits
Medical Investigations

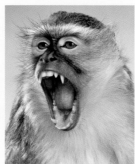

OBI
Vervet Monkey

Residence
Staten Island, NY

Credits
Chapelle's Show
Late Night with Conan O'Brien
Late Show with David Letterman
Corporate events for
 Tommy Hilfiger and Diana Ross
Various print ads
Vanity Fair

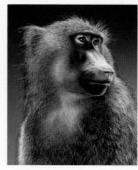

MALA
Yellow Baboon

Residence
Miami

Credits
The Tonight Show with Jay Leno

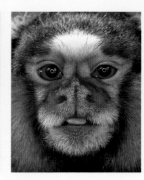

MONA
Marmoset

Residence
Monterey, CA

Credits
Works in Education department
 at Wild Things Animal
 Rentals, Inc.

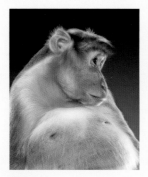

ZACK
Bonnet Macaque

Residence
Miami

Credits
The Simple Life

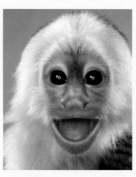

CHITTA
White-Faced Capuchin

Residence
Miami

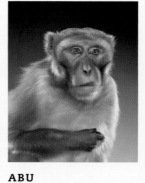

ABU
Golden Rhesus Macaque

Residence
Miami

Credits
Ace Ventura: Pet Detective
The Jungle Book
The Road to Wellville
Carriers

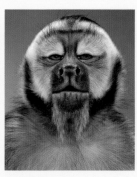

FOREST
Tufted Capuchin

Residence
Los Angeles

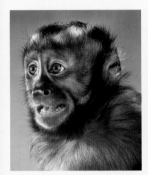

ABBEY
Weeper Capuchin

Residence
Los Angeles

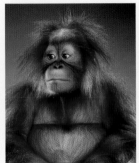

SURYA
Orangutan

Residence
Miami

Credits
Vogue

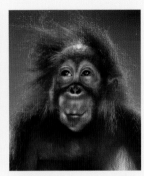

PUMPKIN
Orangutan

Residence
Miami

Credits
The Simple Life

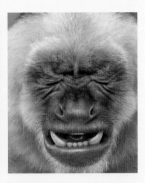

RIPLEY
White-Fronted Capuchin

Residence
Los Angeles

Credits
Gordo's Road Show
"Moldy World"
Morning Fog
Nickelodeon
Honda commercial
McDonald's commercial

ACKNOWLEDGMENTS

I would like to thank all of the animal agencies and trainers who made these sittings possible: Serengeti Ranch, All Tame Animals, Steve Martin's Working Wildlife, Bob Dunn's Animal Service, Benay's Bird and Animal Source, Wild Things A.R., Inc., and Dawn Animal Agency.

I would also like to thank my friend Carah von Funk, who introduced me to Simon Green, who found that Betty Wong and Michael Sand at Bulfinch were interested in making this book with me. Thanks to Gary Tooth at Empire Design Studio, and to Paul Kopeikin at the Paul Kopeikin Gallery for his representation. And special thanks to my husband Robert Green, who supported and encouraged me to do this series.